PART ONE

You CAN PAINT
FLOWERS,
PLANTS & NATURE

NORTH
LIGHT

Cincinnati, Ohio

CONTENTS

HOW TO USE THIS BOOK

Here are 13 step-by-step demonstrations of a range of subjects in different media, designed specially to show you how to paint and draw flowers and nature. To get the most out of these exercises, study each one first and then either re-draw or re-paint it yourself or, using the same medium, apply the same techniques to your own subject.

Copying. Don't be concerned about the fact that you are copying these exercises — many famous artists have used other artists' ideas and painting techniques to develop their own unique style. And copying the exercises will make learning the techniques easier for you as you won't have to worry about finding a subject, composition or design.

Stay loose. It is best to attack each subject vigorously, and aim to make a strong painting. Don't worry about making mistakes along the way — the more you practise and experiment, the quicker and more dramatic will be your improvement.

Experiment. By working boldly and taking risks with lines, colour, shapes and values, you will avoid the risk of your pictures looking tight and overworked. When you are making broad, generous strokes, don't hold your pencil or brush too near the point or your lines and brushwork will look tentative. Only when working on detail should you hold your brush or pencil close to the point – and keep your details to a minimum when beginning a drawing or painting. Usually they are best left for the finishing touches.

Keep it simple. Select simple subjects and compositions to start with. Restrict yourself to a simple range of colours, and keep these crisp and pure by taking care not to overwork or smudge them on the canvas or paper. If you observe these basic points, you will quickly produce surprisingly good paintings and then you can really start to experiment with bolder composition, more vibrant or subtle colour schemes, and develop your unique painting style.

Happy painting!

A QUINTET BOOK

First published in North America by
North Light, an imprint of Writer's Digest Books
1507 Dana Avenue
Cincinnati, Ohio 45207

Second printing 1988

ISBN 0-89134-137-4

This book was designed and produced by
Quintet Publishing Limited
6 Blundell Street, London N7

Typeset in Great Britain by
Facsimile Graphics Limited, Essex
Colour origination in Hong Kong
Printed in Hong Kong by Leefung-Asco
Printers Limited

FLOWERS AND PLANTS

Since cave men first made marks on the walls of their dwellings man has been concerned with depicting the natural world around him. Plants and flowers are excellent subjects to study. They are immobile; many are a manageable size; they are attractive, complex and infinitely varied. On these pages we are using plants and flowers to investigate colour, form, structure and growth — all of great importance to the painter. You can choose your subject from a host of possibilities. There are cut flowers bought from the florist; wild flowers in their natural surroundings; potted plants and window boxes. Whether you live in the country or the inner city, you will never have far to go to find colourful subjects.

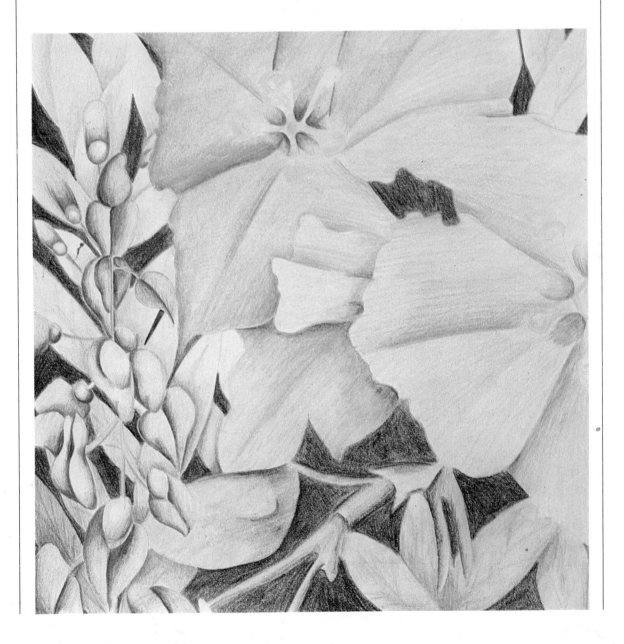

COLOUR IN NATURE

For this study you should choose a plant or flower and make studies of it in different media. Think of the object as a series of colour fields, and look carefully to see how these colours and patterns are affected by different light conditions. You will also discover that the textures of the plant surfaces affect the way light is reflected thus affecting the colour of an area. The perceived colour is also determined by the shape, the size and the surrounding colours.

Try as many different techniques as you can. For example, if you make your study in pen and ink, use as many variations of line and cross-hatching as possible to convey the surfaces and textures.

We suggest you start with a fairly simple plant, or part of a plant such as a leaf or petal. You can then repeat the exercise with progressively more difficult forms.

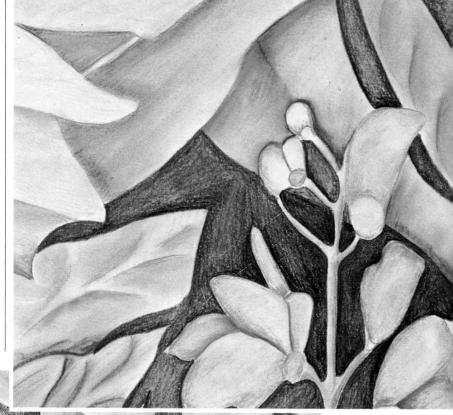

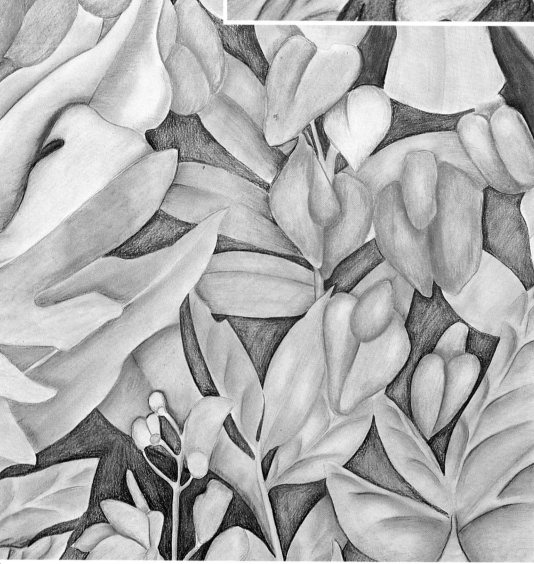

Choose a subject which contains plenty of colour variation and some interesting shapes. Flowers and plants make an ideal subject. Use coloured pencils for the drawing, paying special attention to colour changes and subtle shades of tone within the main shapes (above). Take a wider, more complicated view of the same subject and make a similar drawing, again trying to indicate the complete range of tone and colour within the composition (left).

Make a design from your coloured pencil drawing, this time using tiny squares of paper to represent each colour. Simplify these, using a limited range of coloured papers to approximate the colours in your original drawing (**right**).

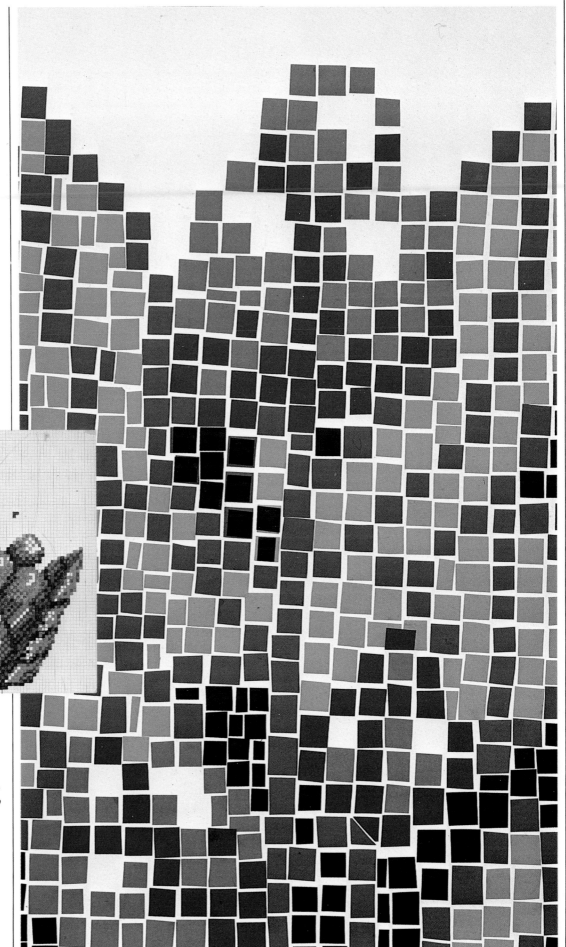

Now make another drawing on graph paper. Choose a range of coloured pencils, and use as many different hues as possible to make the actual colours (**above**). The lines on the graph paper will guide your drawing, leaving you free to concentrate on the colour.

THE WATER COLOUR TRADITION

Water colour is the oldest painting technique known to man, and has been a favourite of flower painters for centuries. In prehistoric times the cave artists of Altamira and Lascaux ground red and ochre pigments from the soil, carbonized wood from their fires, and mixed them with water to paint pictures on their cave walls.

Many ancient civilizations used pigments ground in water and bound with either gum, starch or honey to record great and everyday events. As far back as 4500BC the painters of ancient Egypt used a water–colour on plaster technique, known as fresco to decorate their tombs. They painted in flat colours, predominantly red, yellow or brown ochres, the intensity of which diminished the more they were diluted.

Albrecht Dürer (1471–1528) used water colour extensively and was one of the first artists to fully appreciate the possibilities of the medium, especially for rendering subtle effects of colour and atmosphere — qualities which are especially important to the flower artist.

Until the eighteenth century, despite its long history and its use by such distinguished artists as Dürer and, later, Rubens (1577–1640), water colour was used mainly for the sketches on which more important oil paintings were based. By then the medium was being used in its own right by many European painters, and today water colour enjoys world-wide popularity for its uniquely transparent quality and its incomparable luminous colours.

Water colour can be used in a variety of ways, and is as suitable for intricate, detailed work as it is for loosely applied washes of colour. The two very different paintings illustrated here demonstrate just how versatile the medium is.

The wet-into-wet washes used in the waterlily painting **(below)** *make maximum use of the white paper and the transparency and translucency of the paint. Although to some extent the results of this method are unpredictable — it is never possible to foretell exactly how the paint will dry — each area of colour is carefully mixed and thought out before the artist finally commits paint to paper.*

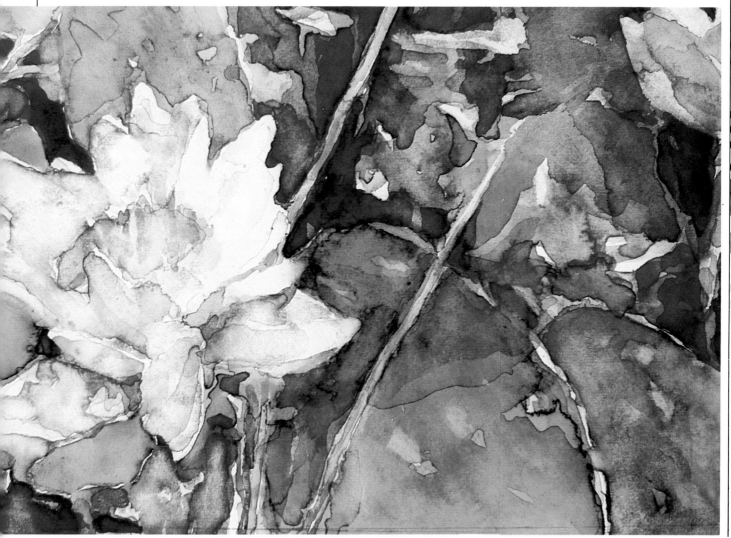

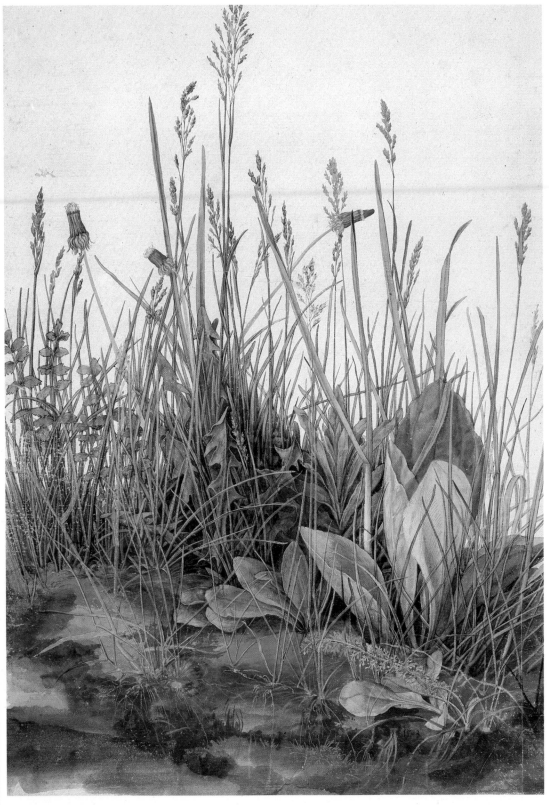

Albrecht Dürer was one of
the first major artists to use
water colour. In his
'Monumental Turf'
(above) he exploited
various types of wash,
linear work and opaque
colour.

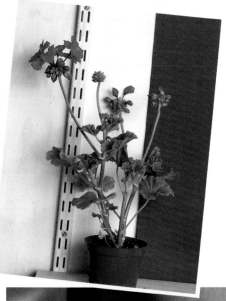

POTTED GERANIUM

The varied textures and shapes make plants and flowers one of the most challenging and rewarding of subjects. You can work from a single bloom or — as the artist has done here — choose something more ambitous and complicated.

Although the geranium appears rather a daunting prospect, with its many leaves and tightly formed flowers, it is quite possible to tackle such a subject by simplifying the complex growth structure into a series of basic shapes and forms. Start by looking carefully at the subject. Decide on the most important elements, such as the main stem and how the leaves and smaller stalks radiate outwards from this, and concentrate initially on these basic aspects.

Pencil is the ideal medium for a sketchbook project such as this one and can be used for a rapid, direct sketch as well as for recording precise information and details.

Although they are not always easy to rub out, pencil marks can usually be removed with a soft putty rubber if necessary. It is undoubtedly useful to be able to make corrections, especially when an accurate and exact drawing is required, but the habit of continual 'rubbing out' is not a good one. A drawing often benefits from lively redrawing, and an over-rubbed work often looks dull in comparison .

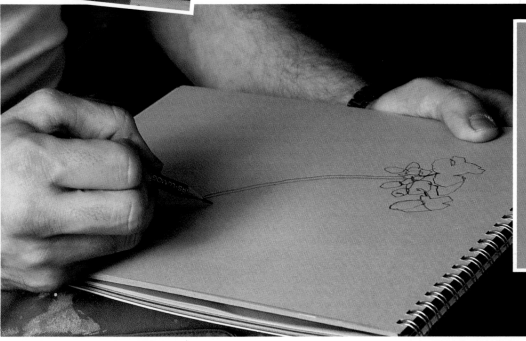

Choose a tinted paper and start by sketching in the main stem and the position of the flowers **(left and above)**.

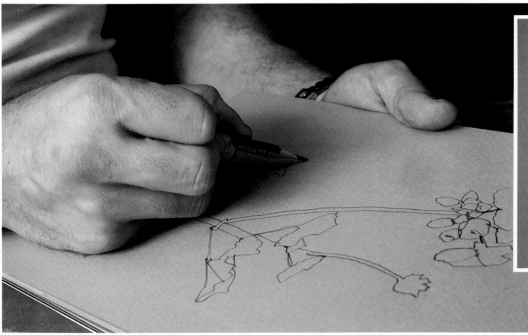

Position the plant in the centre of the paper to avoid the subject looking cramped **(left and above)**.

Use a precise, diagonal hatching to shade in the darker tones of the stem **(above)**. Small areas of selective shading are more effective than too many overlaboured pencil marks, so restrict the hatching to the very darkest shadows, using it to describe the form of the subject **(above right)**. The finished drawing **(right)** is a simple yet precise study of the plant, the emphasis being on the underlying structure and growing form of the plant rather than detail and finish.

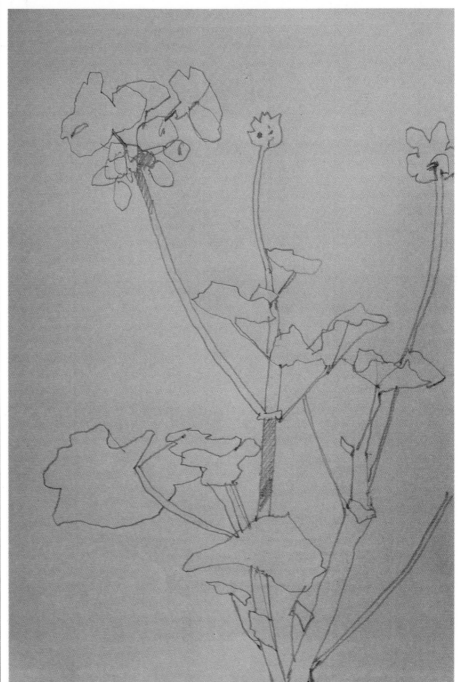

Oil pastels differ radically from pure pastels and chalk. They come in a wide range of colours and sizes, and are usually sold in sets of 10 or more. Oil pastels are a comparatively recent innovation and have gained popularity with painters as a useful medium for preliminary colour sketches. Their bright, strong pigments blend well to make areas of flat colour, or can be used for linear drawing. The potted palm **(below)** *offers scope for using both line drawing and solid blocks of colour.*

Working on tough granular paper begin to sketch in the main areas of the subject. Vary the colour of the outline to match the local colours, but without being too literal or precise about this **(left)**.

Exploit the brilliant colours of the pastels by exploiting what you see **(left)** *— for example, a muted bluish shadow could be rendered in brilliant blue. Work into the drawing with different tones of the same colour* **(below)** *to create form. An effective way of doing this is to use a light, medium and dark version of the same colour to indicate rounded form instead of introducing dull or neutral colours for the shadow areas.*

POTTED PALM

Oil pastels are excellent for quick sketching — on those occasions when it is essential to put down information quickly, and when detail is not important. It can also be used in conjunction with oil paint — many artists use the pastels for adding linear details to the finished oil painting.

Use turpentine with the pastels to get a smooth, untextured finish. First work into the area with dense oil pastel (**right**). Pour a little turpentine into a wide-necked container for easy access (**below**).

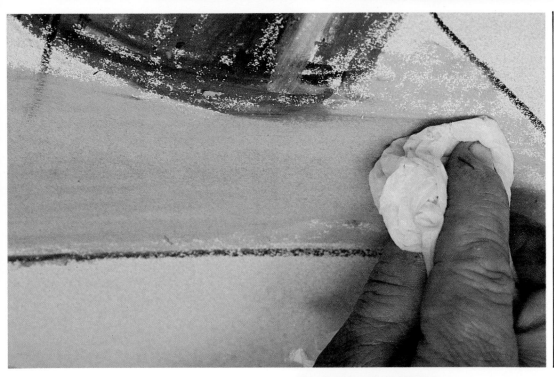

Dip a clean rag into the turpentine and carefully wipe the pastel (**left**). For smaller areas use a brush instead of cloth to dissolve the pastel.

Work into the flat area with more colours — use two or three colours together if you want, but remember that the turpentine will blend them together into one flat colour. Add shadow areas by using dark colours, laying the pastel in long, even strokes (**right**). For lighter, more transparent tones, use the colour sparingly.

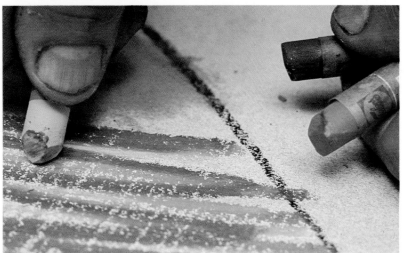

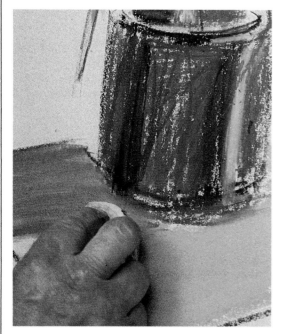

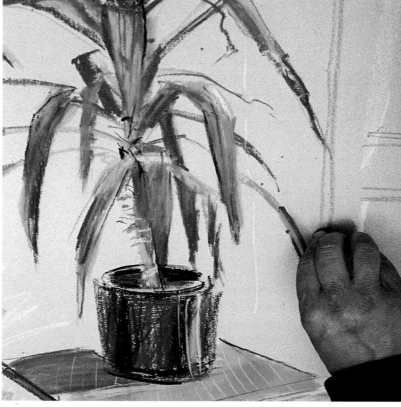

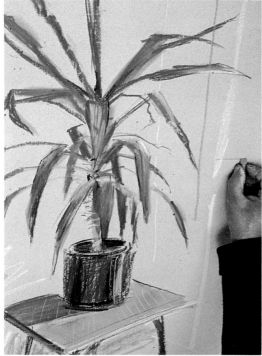

Wipe the newly applied pastel with the cloth dipped in turpentine **(top left)**, *to obtain shadow. Keep the background light and simple* **(top right and above)**, *suggesting shapes in a sketchy way rather than in solid, bright colour which would distract attention from the subject and confuse the composition. Successful use of oil pastels can involve many different colours, which mix together on the support, without becoming clogged or muddy* **(right)**. *The medium allows the combination of the dense, bright colours of painting, with the lighter sketchy qualities of drawing* **(far right)**.

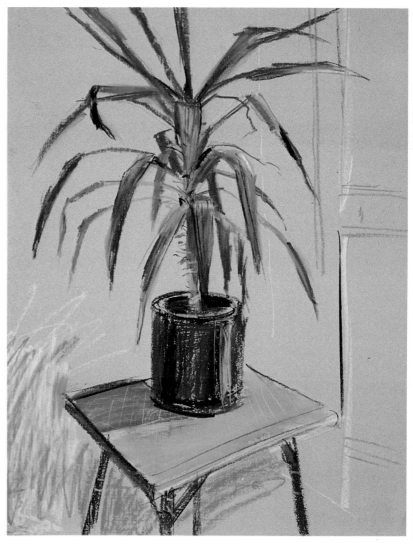

CUT FLOWERS

Brightly coloured cut flowers provide an endless source of delight and challenge for the artist. Their brilliant petals and varied organic shapes demand a medium which not only provides the necessary range of vivid colours, but is also capable of producing the subtle tonal differences which sometimes occur within quite small areas.

It is here that pastel really comes into its own. Pastel colours are almost pure pigment, and their fine graphic qualities allow you to make strong, linear statements as well as lending themselves to the creation of vibrant areas of flat colour.

The colours used in this picture are basically the 'complementaries', those colours which lie opposite to each other on the colour wheel. Particularly dominant here are red and green; orange and blue. It is worth remembering that colour is created by light, and colour will always reflect and bounce off neighbouring colours.

In this picture the artist has exploited this fact by using a complementary colour within a predominant colour area. Thus there are touches of red in the blue and green in the orange and red flowers, and touches of red and orange in the blue flowers and green foliage.

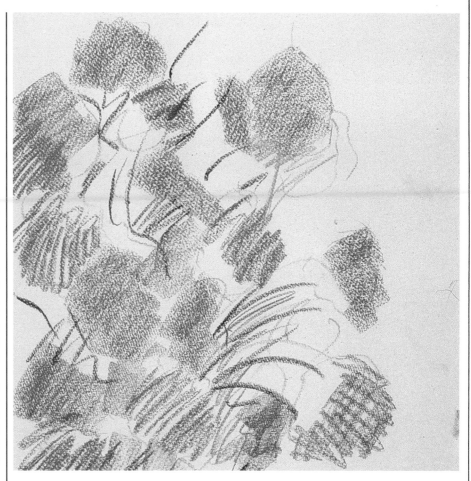

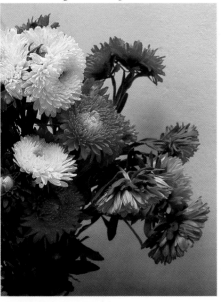

Bold shapes and colours make these flowers **(above)** *a perfect subject for pastels. Start by roughing in the shapes with charcoal, then lightly sketch in the colour—pink, red and purple for the flowers, and light and dark green for the stems* **(top)**. *Work into the purple flowers with pale blue, drawing the petals with sharp strokes* **(bottom)**.

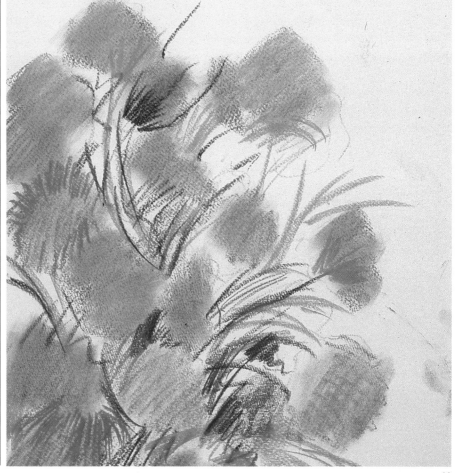

Blend the colours with tissue to lighten the tones **(left)**. *Unlike your fingers, tissue picks up the grains of pastel, allowing the paper to show through.*

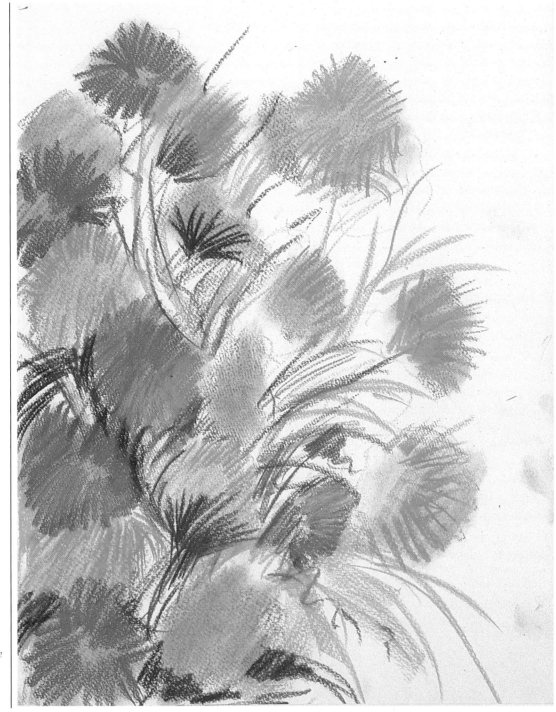

Working with short, sharp strokes, use cadmium red and orange to emphasize the petal shapes. Define the stems with dark blue—still using the same sharp, directional strokes **(right)**.

14

Use the tip of the pastel to obtain the fine, linear quality of the leaves **(above)**. Strengthen the flower tones, blending them where necessary to contrast with the foliage **(right)**.

With purple pastel, draw a heavier tonal layer into the blue flowers—use the same colour to loosely sketch in more leaf and stem shapes **(right)**.

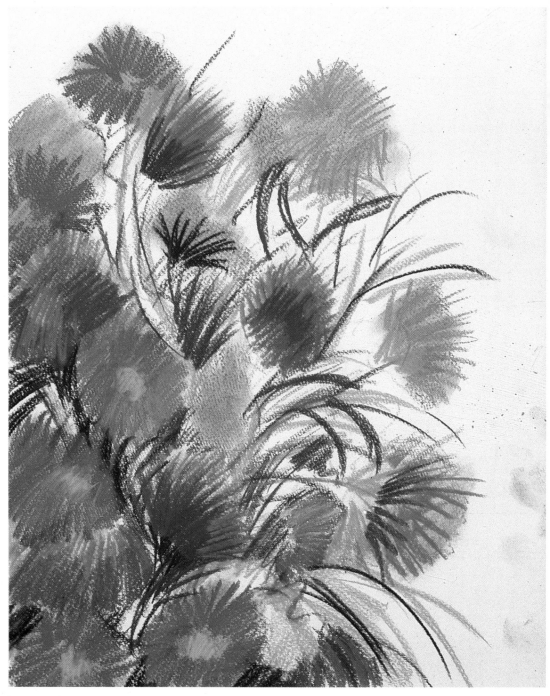

Returning to the flower heads, apply more pressure to the pastels to obtain deeper tones. Add touches of red to the purple flowers and put yellow centres in the paler ones **(left)**.

16

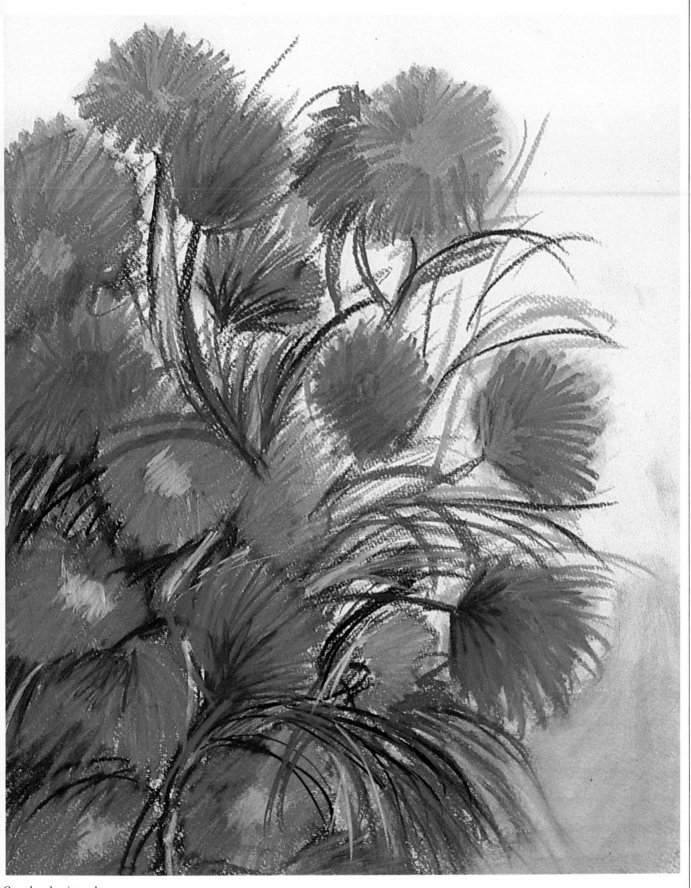

Complete the picture by
toning areas of background,
breaking up the flat, white
area around the flowers to
create a spatial setting for
the subject.

RHODODENDRON IN A GLASS JAR

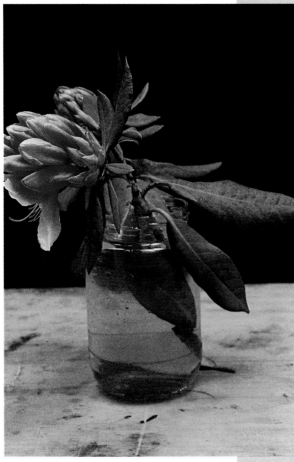

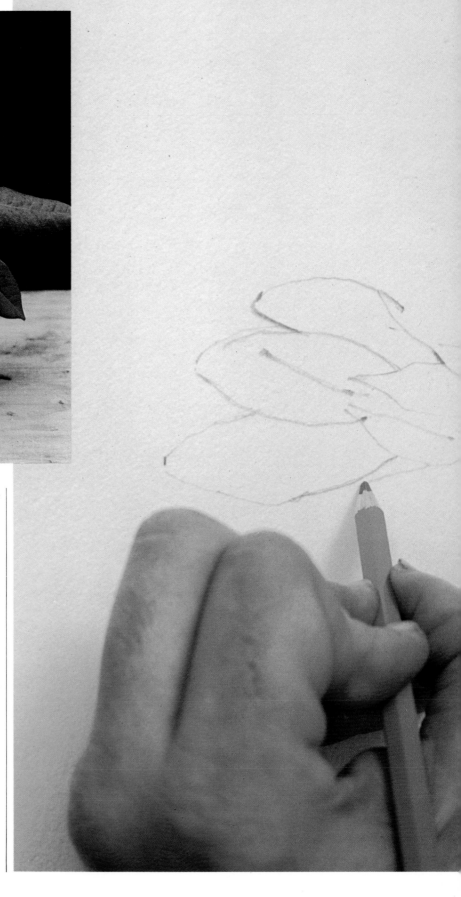

Watercolour pencils have many of the advantages of real water colour with few of the drawbacks. By using water with these pencils you can dissolve light pencil strokes, blending the colours to get the effect of a watercolour wash.

This compact and versatile medium is especially appropriate for fine, detailed work such as flower drawing, and is really at its best when used for exacting, small-scale work such as this intricate rhododendron. However, used more freely, they are an ideal tool for the sketcher who can use them to make on-the-spot colour notes without the encumbrance of a set of paints.

Watercolour pencils can be used to subtly soften the effect of a pure line drawing. You do this by gently working water over the finished drawing with a fine sable brush. By applying water to certain areas only, you can vary the textures and adjust the tonal contrasts of the whole composition.

You can also use water to blend two or more colours together, something which is impossible with ordinary coloured pencils.

Draw the outline in deep pink (left). It is important to use a similar colour to that of the subject because the outline will eventually be blended in to form part of the finished image.

Your outline should be strong enough to act as a positive guide for the rendering (right), but not so dark that it will affect or dominate the completed picture. Now, pick out the areas of subtle colour with the appropriate pencil, using light, even strokes (below).

Choose each tone and colour carefully, referring continually to the subject (**above**). Use a sable brush dipped in clean water to blend the colour (**left**).

Blend one area at a time, paying attention to the form and tonal variations within each small shape (**above**).

Alternate between the brush and pencils as you work, gradually developing and darkening the colours without affecting the delicate balance of tone within the flower (**above**).

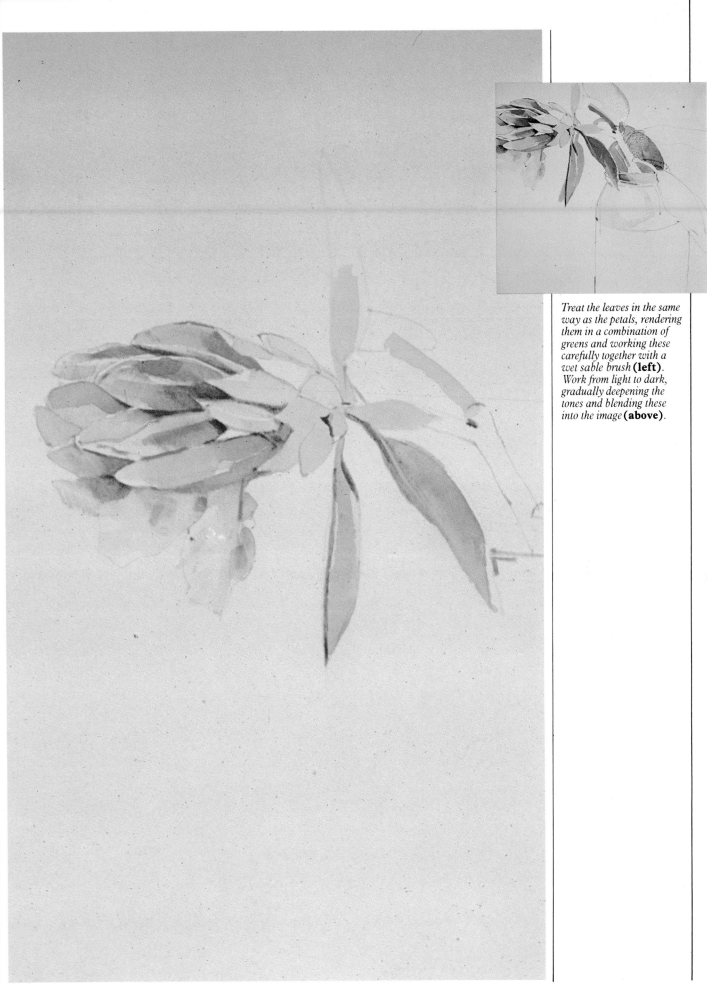

Treat the leaves in the same way as the petals, rendering them in a combination of greens and working these carefully together with a wet sable brush **(left)**. *Work from light to dark, gradually deepening the tones and blending these into the image* **(above)**.

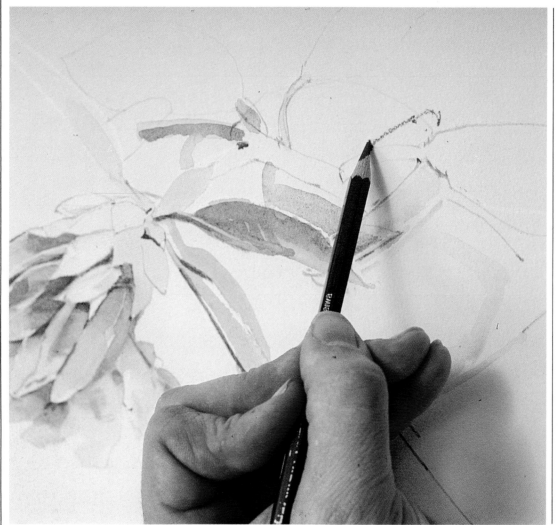

*Before moving on to the background, sketch in the shape of the remaining leaves (**left**). These will be left unfinished—as white silhouettes—to contrast with the highly rendered finish on the rest of the flower.*

*Start to blend the background texture with water (**below**). Take the wet brush right up to the edge of the leaves and petals, redefining the rounded shapes with careful, curving strokes.*

*Use a free cross-hatching movement to block in the background area (**right**). The tones nearest to the subject should be especially dense, thus enabling the shape of the flower to stand out clearly from the dark background.*

22

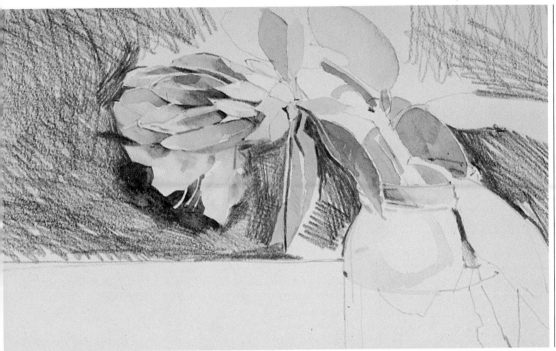

Be selective when adding water to the background. A flat, empty expanse of black can be avoided by blending only certain areas, leaving some of the background as roughly scribbled pencil marks. The final picture **(below)** benefits from a rich variety of texture which creates a harmonious balance between the elaborate detail in the flower and spontaneous drawing elsewhere in the picture.

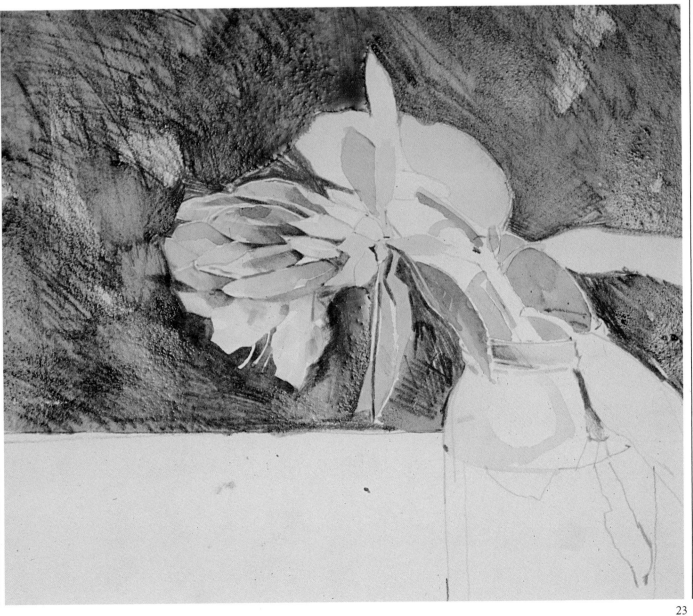

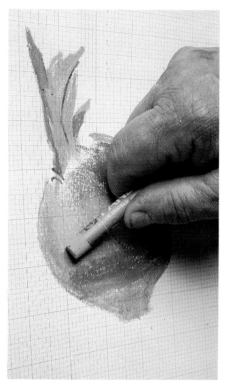

ANALYZING COLOUR: A DIVISIONIST EXERCISE

Divisionism is based on the fact that the more colours are mixed together, the darker the resulting hue.

Mixed pigments appear darker because the amount of light they reflect back to the eye diminishes proportionately with each additional colour in the mixture. (Coloured light reacts in the opposite manner — 'additively' — so that adding colours of light together produces an increasingly pale mixture, resulting in the pure white light which is a reconstitution of the entire prismatic rainbow). For the painter, therefore, the less actual mixing of paint which takes place, the lighter and brighter the resulting picture will be.

The Neo-Impressionists were even more rigorous in their attitude towards colour mixtures than were the Impressionists. The latter often slurred together or even pre-mixed complementary colours — such as blue and orange, and red and green — to give colourful neutral grey hues.

Seurat's mature Pointillist technique, in which almost uniform mechanical dots of pure colour were built up over the entire paint surface was a methodical application of coloured dots which minimized the darkening, and consequent dulling.

Without imposing extreme limitations on your work, it is generally impractical to avoid mixing your own colours. However, it can be useful to understand the principles of divisionism, or 'optical colour mixing' as it is often called. This simple exercise will help you to apply pure colours separately so that they mix in the painting rather than pre-mixing the colour on the canvas. If you look closely at the final drawing of the onion, you will see how the artist has managed to create a realistic image using fragments of pure colour with relatively little mixing.

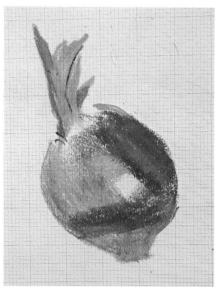

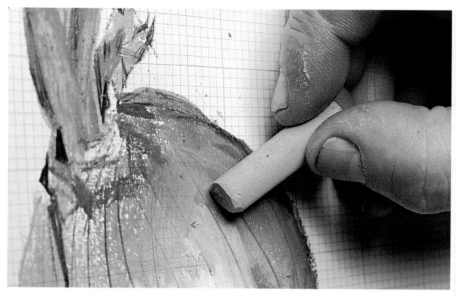

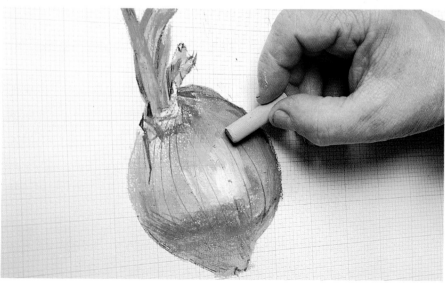

For this exercise, start by making a coloured drawing. This will eventually be interpreted in a second drawing in which areas of colour are broken down into dots, or points, of pure unmixed colour. Use pastels on graph paper for your initial drawing. The pastels allow plenty of colour variation and you can change easily from one colour to another as you work. Block in the colours in positive, bold strokes **(top** *and* **above),** *allowing the white paper to show through for highlight areas* **(above right)** *and blend pastels by superimposing thin layers of different colour* **(right)**.

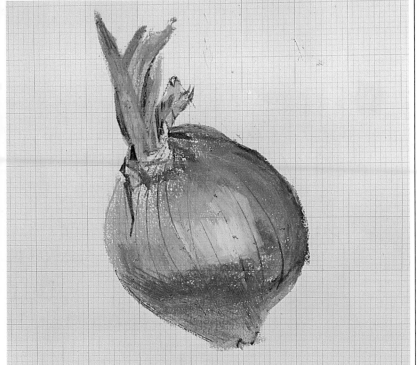

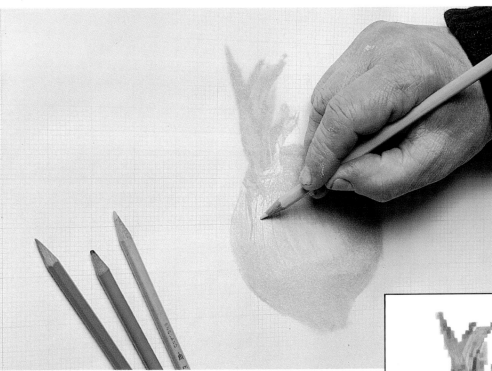

Do not attempt to put any background into your work. For this initial exercise, leave the subject against the white background (**top left**). Place a piece of tracing paper over the finished sketch (**above**) and tape it firmly so that it stays in the same place without slipping.

For the next stage of the project, use well sharpened coloured pencils. Carefully examine the colours of the drawing through the tracing paper, paying particular attention to tiny variations in the different squares on the graph paper. Choose the colour from your set of pencils which most closely resembles the colour mixture across each tiny square — only where you cannot match the colour should you resort to mixing.

Continue building up your diagram in this way, following the square on the graph paper where possible. This will enable you to concentrate on the colour without having to worry about form (**above**). The end result (**right**) is a graphic interpretation of the onion, with the colour reduced to tiny squares of colour. If you observe this from a distance or look at the picture through half-closed eyes, the onion will

cease to be a flat design; the colours will appear to merge, turning the subject back into a realistically rounded form.

MEASURING AND MARKING

In order to draw this bunch of flowers, the artist eliminated from his mind any prior knowledge he had of the subject and focused his mind on the flowers as if they were an abstract. As he drew, he made a series of marks, relating the position of one component to another by continually measuring and dropping plumb lines.

This method of 'measuring and marking' will enable you to produce accurate drawings. A possible disadvantage is that its continual use may lead to an unselective, map-drawing way of working. Accuracy is not the only criteria of a good drawing and the technique should therefore be regarded as a means rather than an end in itself.

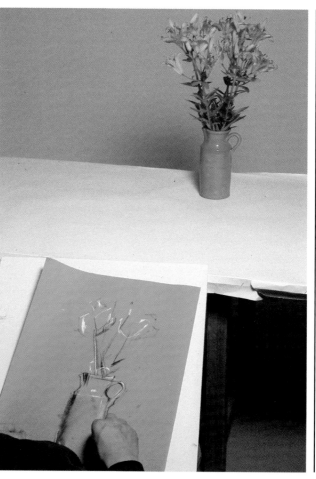

When drawing a complicated subject such as this vase of lilies it is often easier to mark in the positions of the key points before committing yourself to the final lines. Start by marking in the positions of the blooms in relation to the stems **(far left)**, *using black and white to help you to differentiate between different sets of marks* **(bottom left)**. *Draw the vase and use this as a fixed point of reference* **(left)**. *Continue to mark in the flower positions, relating them to each other and making corrections where necessary* **(below)**.

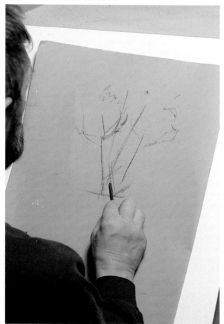

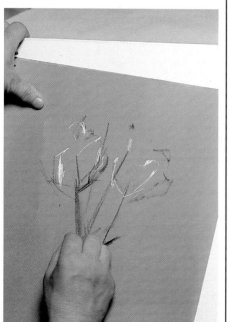

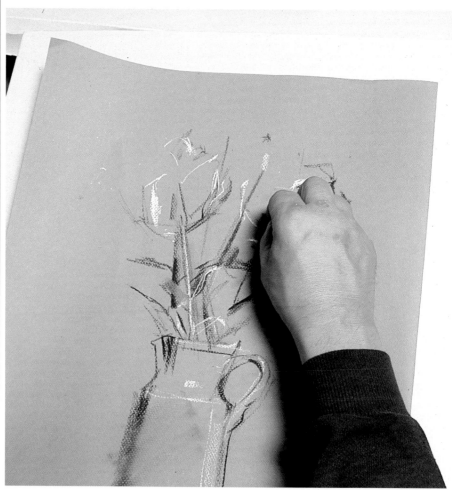

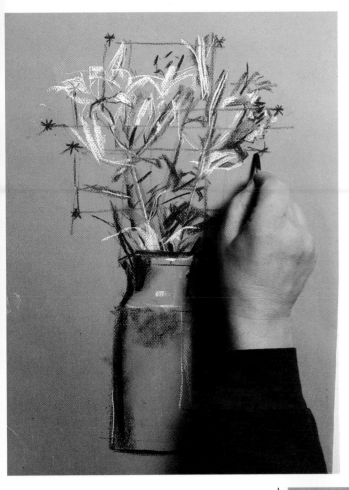

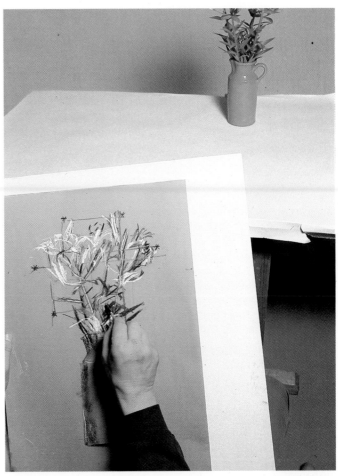

Begin to build up a series of construction lines, using your pencil or charcoal to measure the distance between different points **(above)**. Using the marks and guidelines which you have already established, continue working the flowers so that the image emerges clearly from the paper **(top right)**. The completed picture **(right)** is an accurate working sketch of a vase of flowers. It includes enough precise information about the subject to use as the basis for a painting or, by clarifying the details and removing the construction lines, can be developed into a more refined drawing.

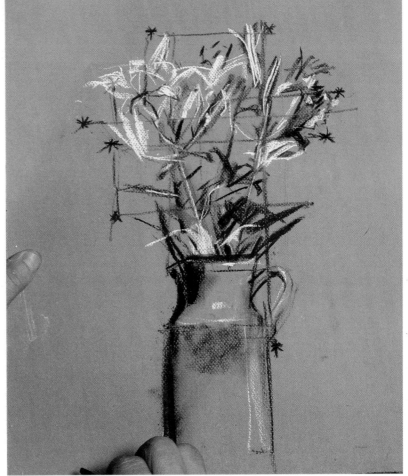

FLOWERS IN A WINDOW BOX

Water colour has a bright translucent quality ideally suited to flower painting. Traditionally, the transparency of the paint is used to create both colour and tone — white is banned from the palette in pure water colour painting. White mixed with water colour creates an opaque effect which is similar to gouache. Thus, when you are painting in pure water colour you must rely on your skill in using the whiteness of the paper for the light tones and highlights.

In this painting the artist works from light to dark — a traditional water colour technique. By starting with a series of very light washes, it is possible to build up the tones gradually, retaining complete control over your work. Remember, you cannot paint a light tone over a darker tone with water colour so work cautiously, painting layer upon layer of thin colour until you achieve the correct density of colour and tone.

Practice and experience will help you to handle and control the paint, but water colour is an unpredictable medium, and there is always an element of surprise which adds charm and excitement to the work.

For this colourful flower subject (above) try to include as many different water colour techniques as possible, making maximum use of the medium as well as improving your own skill in applying them. Notice how the flower and leaves are restricted to a few basic colours, but that each of these is broken down into several variations and tones. Start by blocking in the palest tones visible on the actual subject with a very pale wash (below).

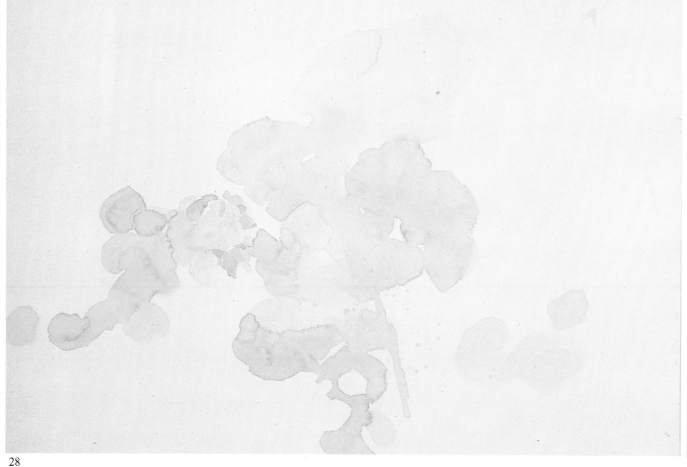

Always work from light to dark when painting with water colour. The whiteness of the paper should be used instead of white paint. Water colour mixed with white loses its transparency and takes on an opaque quality similar to that of gouache. To obtain pale colours dilute the paint, making it transparent enough for the white paper to show through and lighten the colour (**right**). Keep the shapes as general and loose as possible at this stage (**below**).

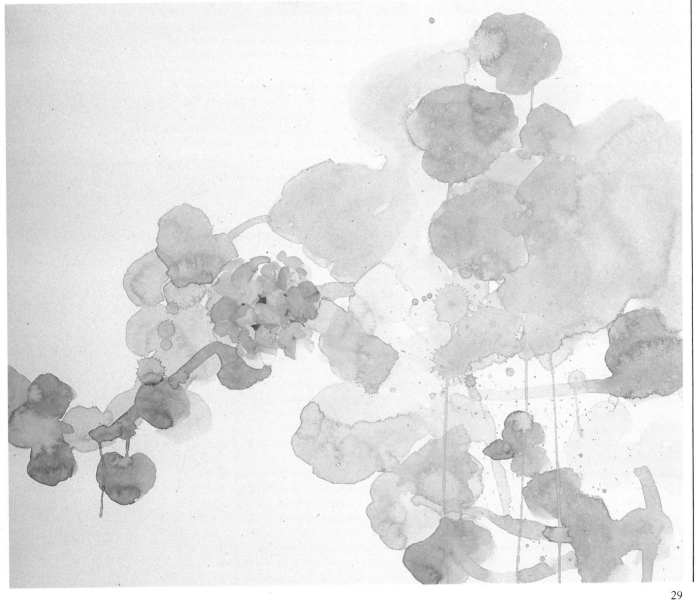

Mix a large quantity of background tone—the artist here used Payne's grey and cerulean blue—keeping the colour very thin. Apply this quickly with a large sable brush, laying the paint as transparently as possible **(above)**. Work into the leaves, developing their dark tones, allowing the colours to bleed into each other **(below)**. With a fine brush, apply the details of the stems and leaf veins in a clear, dark colour **(right)**.

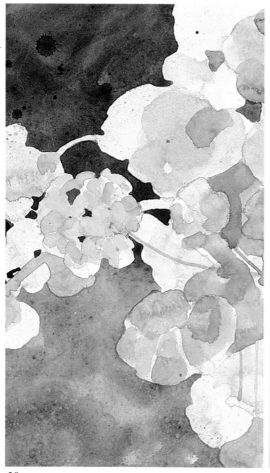

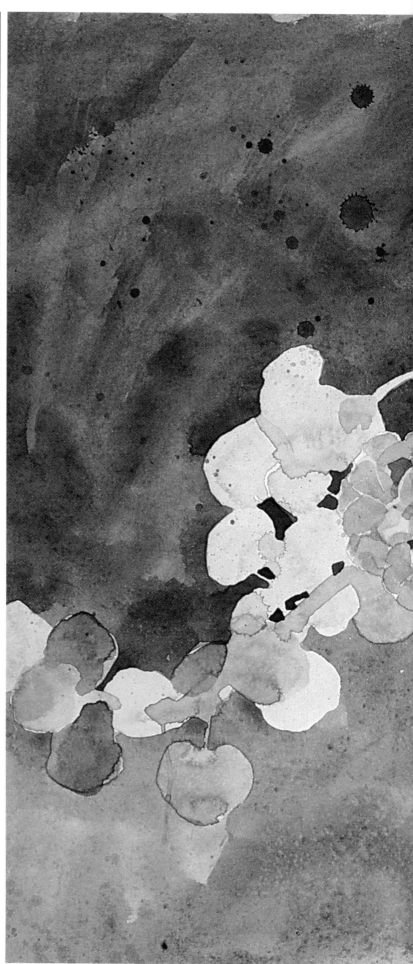

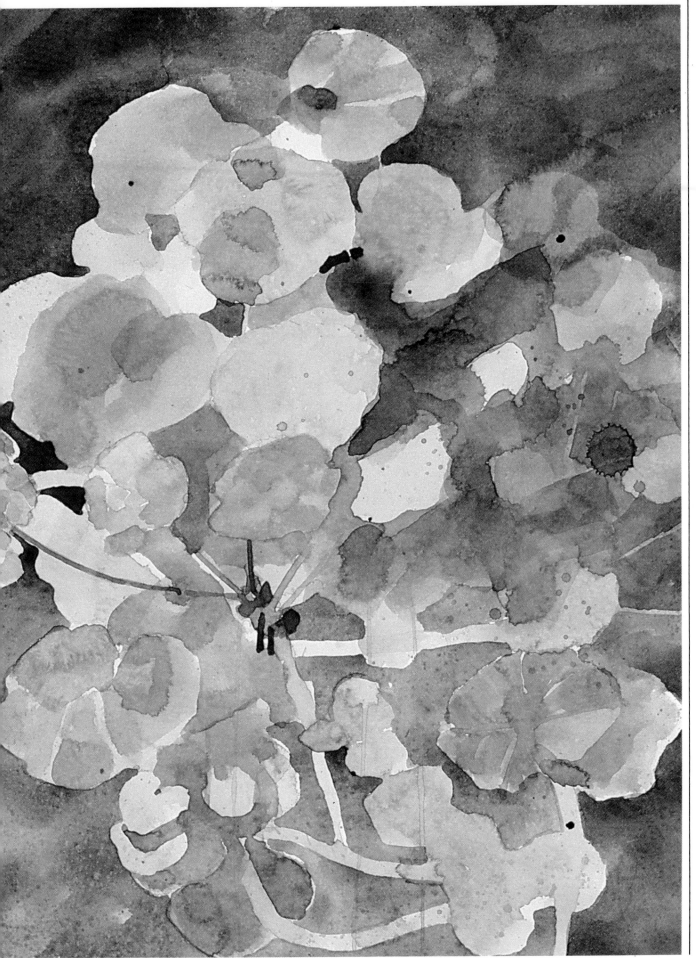

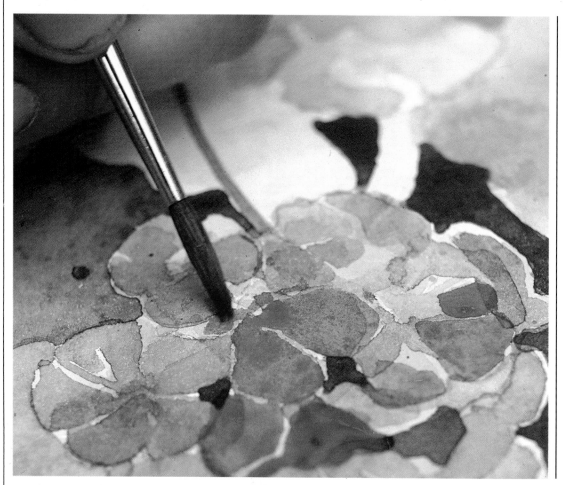

Still using a small brush, touch in areas of deep red over the lighter underpainting of the flowers (**left**).

Extend the background and develop details across the whole image, defining and strengthening the tones to bring out the crisp shapes of the flowers and foliage (**below**).

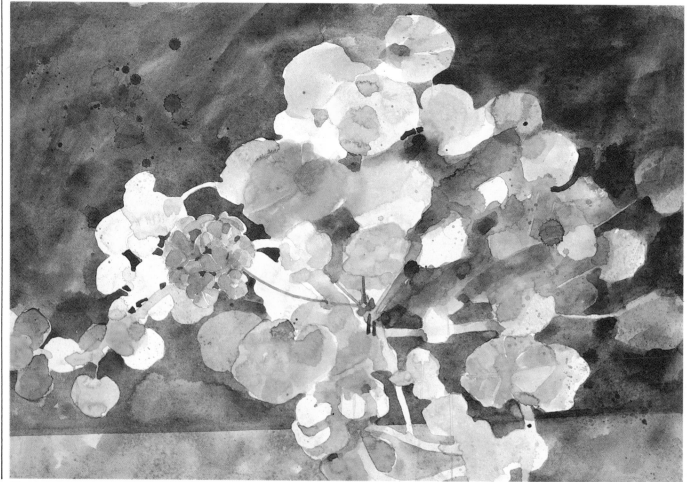

NATURE

NATURAL FORMS

Artists of today are free of many of the conventions that placed limitations on painters of previous generations. 'Working from nature' is a broad term which not only includes making literal pictures of plants, flowers, wildlife, and so on. In its wider sense it also means studying structure and organic growth in all natural objects. Of course this wealth of opportunity and wide choice of subject can be confusing and bewildering, and no amount of freedom of expression or individuality can get away from the need for close observation and accuracy when working from nature.

Colour is crucial, and its contribution to the natural world cannot be overstated. To the artist the colour, structure, mood, design and texture cannot really be studied in isolation. In the painting below the artist has used a low-key palette and, although the colour and tone have been freely interpreted, there is an underlying tautness — the result of careful attention to form and the underlying structure of the subject. Here the palette is deliberately restrained. Even if you delight in rich, vibrant colours, you should also sometimes experiment with a different colour range to avoid the automatic repetition of too familiar colours. Use natural shapes as vehicles for investigation — as the artist has done here — and take an imaginative and interpretive approach to the subjects. These pictures clearly demonstrate the fact that there are no rules in painting. As long as the final result works, the method — no matter how unusual — is justified.

Many natural forms are alive. Flowers and plants, for example, are growing organisms and are usually best left in their own surroundings while you paint or draw them. Potted plants are an easy and convenient source of subject matter, and providing you water them and keep them in a suitable temperature, can last for a long time.

Other natural forms, such as stones, pieces of driftwood or fossils, are inanimate and can be collected and taken home, thus enabling you to become completely familiar with them and to spend time studying their forms and shapes in the comfort of your own home or studio. Many artists have a huge selection of such things, standard favourites which they use time and time again, often as part of a larger composition.

A scientific curiosity about the things you draw and paint will often help you to understand why and how your subject came to be a certain colour or shape. Of course, you do not need to be an expert in botany or geology to enjoy working from plants and rocks, but it often makes a subject more interesting if you know a little about its origins.

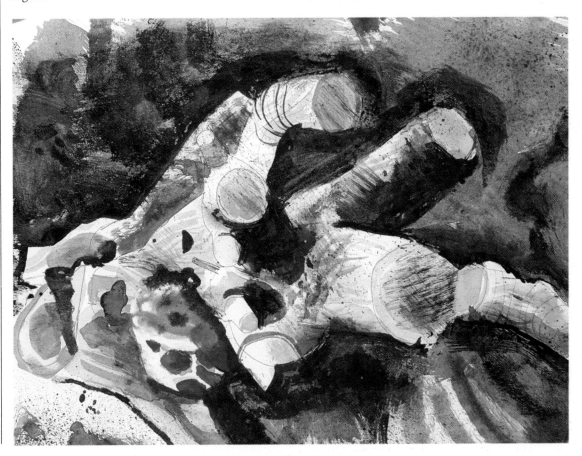

ABSTRACTION FROM NATURE

The painting at the top of the page is an exercise in the use of unusual, though mellow colours. The warm pink and the muted yellow is a highly individual choice, an unusual and imaginative interpretation of the neutral tones which existed in reality. Without losing the character of subject — a gnarled piece of driftwood — the artist has taken it out of its normal environment.

This transformation, by means of changing and adapting natural colour, is usually most successful when other characteristics of the subject are preserved. In these paintings the artist has used the subject, fragments from nature, as a starting off point for the pictures. They are not totally abstract concepts, but a personal vision of ordinary things, and certain elements have been isolated, exaggerated or subdued in the interests of the whole.

For instance, texture plays an important part in all the paintings shown here. The artist has used various techniques and different media to achieve decorative, grainy effects which are crucial to these imaginative compositions, but would probably have been less important in a more realistic, representational painting. Although many of the colours bear little or no relation to those actually present, the textures — though exaggerated — are generally faithful to reality.

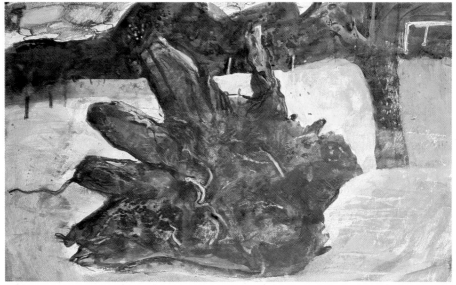

A simple monoprint was the basis for the colourful picture of a piece of driftwood (above). This was worked into with paint and chalk to develop the texture and tones of the subject. A second picture of the same subject (left), was done in gouache, ink and charcoal. Like the picture (below), the colours are bright and slightly unnatural, but care has been taken to retain the organic character of the subject.

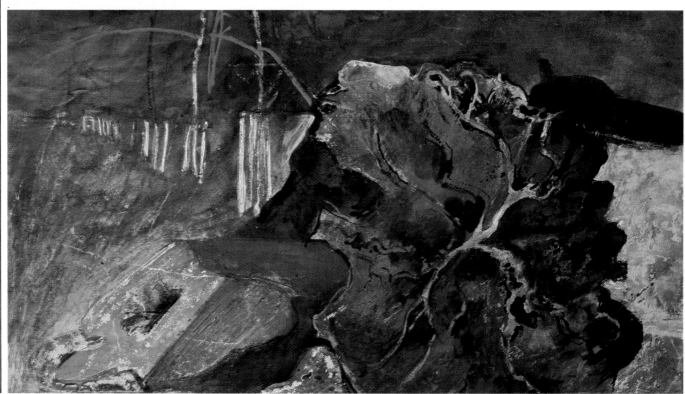

A gnarled tree stump provided the inspiration for this unusual and imaginative mixed media painting. The initial blocks of colour were worked over with pen and ink, and the colour scratched with a pen nib to provide texture and to reveal the underlying painted colours.

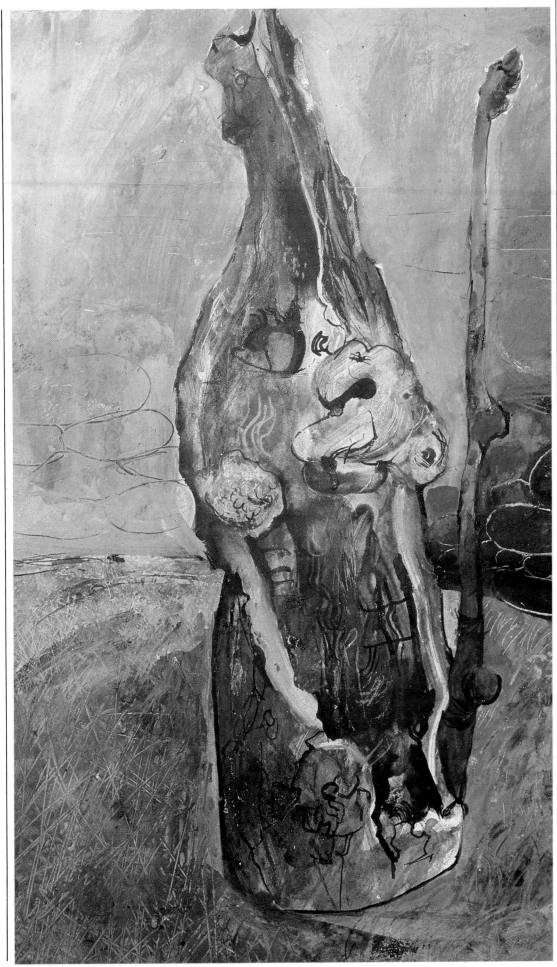

LOOSENING UP

Starting to paint or draw can be a frightening business, confronting you with a spotless canvas or piece of paper and defying you to make the first mark! It is all too easy to start work in an over-cautious way on one small area, and to spoil your picture by overworking almost before you have begun. We suggest a quick 'loosening up' exercise to put you in the mood and to get rid of those inhibitions.

This rapid colour sketch was done with oil pastels — a chunky medium which demands a spontaneous and un-premeditated approach. Our artist worked on tinted paper to soften the effect of the pastels and to avoid tackling an area of bright white.

Keep your materials as simple as possible — a vast choice of colour is not essential and will take up time as you stop to think and select which pastel to use. Our artist used just six sticks of pastel, using them to give a general impression of the local colour, light

1

2

and shade rather than a detailed rendering of the subject.

Keep your drawing as loose as possible. The medium will make it difficult for you to become over-obsessed with isolated parts of the drawing, but you should also make a conscious effort to treat the subject in the broadest, most general terms. Avoid the temptation to draw a precise outline — this will immediately tighten the image and inhibit your pastel strokes. The initial outline should be kept to a minimum — in this sketch the artist started immediately by blocking in the main areas with blocks of colour.

The more you are able to relax and enjoy what you are doing, the sooner you will lose the self-consciousness which prevents you from developing your own personal style. A looser approach to your work will come with experience and increased confidence, and exercises such as this will help you achieve that.

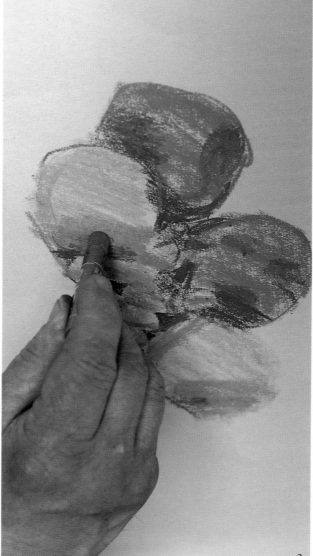

3

1 *Choose a simple subject, putting a selection of objects together without too much thought to the arrangement. Avoid working on a bright white paper as this can be unnecessarily daunting for a quick sketch. Choose instead a tinted paper which is sympathetic to the colours you are using. Now, working very quickly, start to block in the main areas of colour in bold, free strokes. Outline should be kept to absolute minimum — the artist here is working mainly without outline.*

2 *Work into the objects, still treating the subject in broad, general terms. Shadow is depicted in areas of bold red. The artist suggests the rounded forms of the fruit in the simplest terms by working into each fruit with a different tone. Here, a deep yellow is loosely applied to the shaded side of the grapes.*

3 *Gradually build up the density of the colours to describe more precisely the form and volumes of the fruit. Notice how the artist still works in general terms creating a more solid form without using detail or changing to a tighter manner of working.*

4

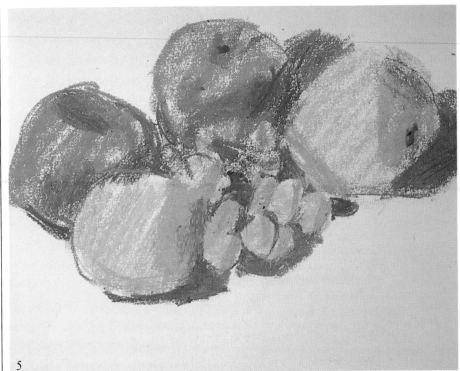

4 Continue to work freely in broad, directional strokes. Layers of pastel are built up to strengthen the image.

5 Shadows in between the fruits give depth to the subject. Again, do not draw these in intricate detail.

6 The completed sketch — broad, flat shapes applied quickly and confidently in a few colours.

5

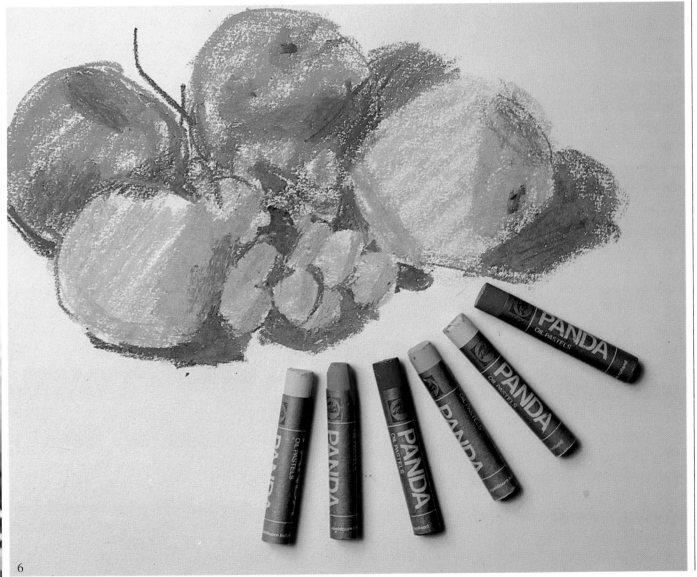

6

HORSE'S HEAD

Pen and ink is a direct and bold drawing medium and requires a degree of confidence on the part of the artist.

It is not easy to make corrections when using ink. Small mistakes can be painted over with a thin layer of white gouache, but the paint must be applied sparingly because you cannot use ink over a thick layer of paint and a drawing quickly loses vitality if there is too much painting out.

Generally it is better to avoid too many corrections, re-establishing a wrong line with a second confident stroke instead of trying to hide the mistake altogether. This may result in double, and even triple, lines but these will often enhance the drawing and give it a liveliness and sense of movement which too much painstaking covering up can destroy.

Your composition can be sketched out lightly to establish the proportions and relationship of objects, but this should only be a rough guideline. The purpose of the exercise is not to trace over a pencil line, but to explore the potential of the medium through direct drawing.

The loose line and confident strokes which experienced pen and ink artists achieve are acquired more by a relaxed attitude than superior drawing talents. More than any other medium, if the artist is worried about the strokes, the pen and ink drawing will immediately reveal that concern. You must make a conscious effort not to control or inhibit the line of the pen and the flow of the ink, and to allow the lines to flow naturally.

Here the artist has achieved an informal sketch with little detail or careful rendering. The strokes are loose, flowing and uninhibited, perfectly capturing the character and form of the horse.

Lightly sketch in the outline of the subject **(below left)**, *keeping the drawing as simple as possible and without including any detail. Use a fine nib to cross-hatch the details within the main form, such as the area surrounding the eye* **(below)**. *Work down the head indicating the muscles with a light, diagonal stroke* **(bottom left)**.

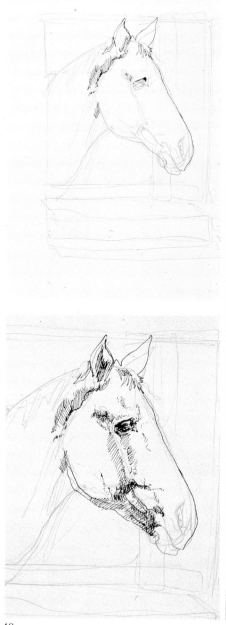

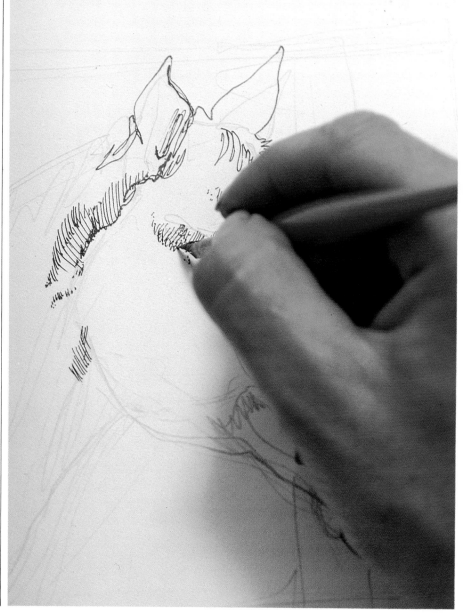

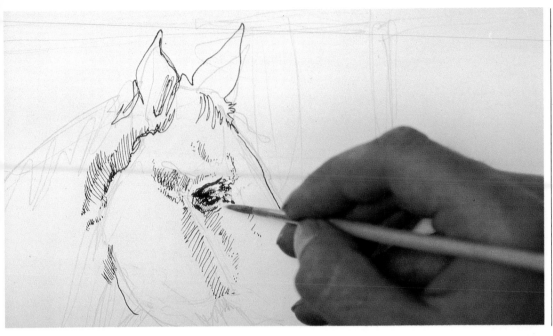

Small mistakes can sometimes be corrected by using a small brush and white designer's gouache **(left)**. *Such corrections should be kept to a minimum as too much white paint becomes difficult to draw over.*

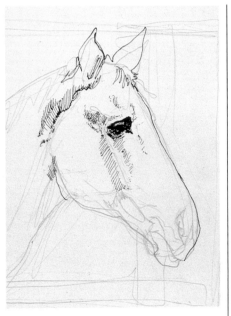

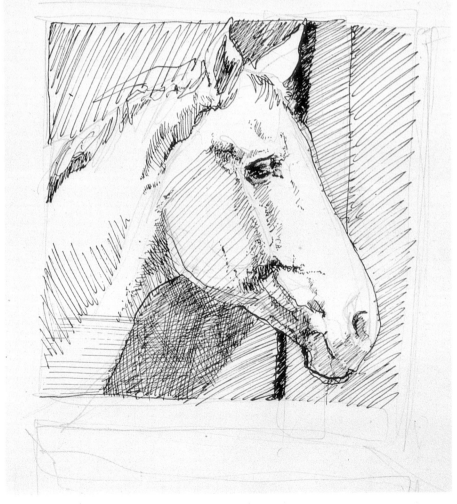

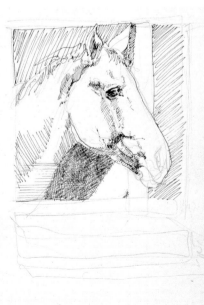

Continue working into the tones **(above left)**, *developing the planes of light and shade without allowing the drawing to look overworked.*

Put in the darkest areas with a scribbling motion and plenty of ink. Redefine the outlines of the head with dense, dark line **(left)**.

Complete the picture by creating darker tones and shadow areas, working back into the head and surrounding with systematic cross-hatching **(above)**.

CHIMPANZEES

Living creatures are not the easiest of subjects to paint. They move around, and often the only way to capture them is to work from sketches and photographs or — as the artist did here — to paint quickly whilst the animal is engrossed in something else. The chimpanzees were painted on the spot, but the artist took the canvas back to the studio to complete the more complicated background textures and tones.

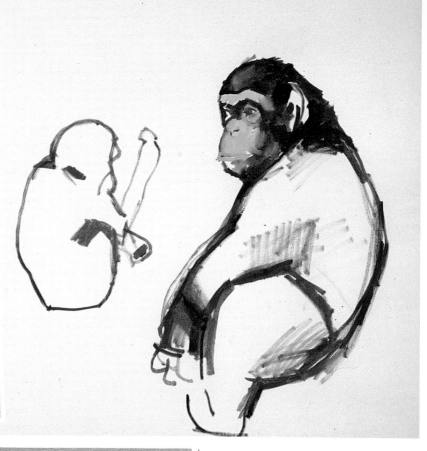

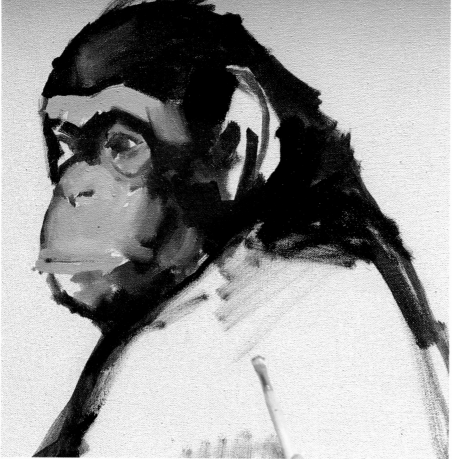

Oil paint is particularly suitable for this rapid, sketchy approach and can easily be manipulated and moved around the support to quickly establish the main shapes and forms. In this painting the artist blended and streaked the paint to create an impression of soft fur. Although dark brown and black fur often looks flat because it absorbs most of the light, there are usually slight variations of tone and colour within the main shape. The artist has used these to help describe the form of the animals.

Working quickly, block in the outline of the animals using a No.4 bristle brush and diluted black paint **(top left)**, *sketching in the approximate tone and colour of the skin and fur* **(top right)**. *Use a No.6 bristle brush to broadly indicate the nature and position of the features. Keep the painting general at this stage, without worrying about the unfinished appearance of the painting* **(left)**.

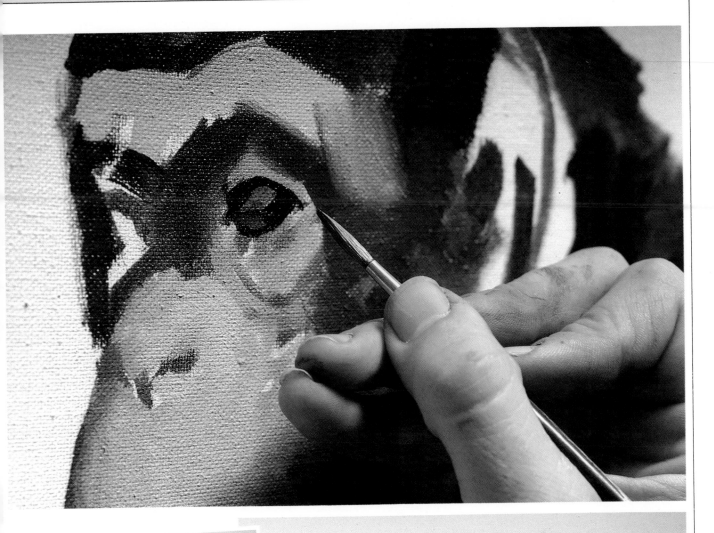

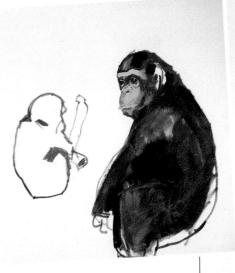

Use a small sable brush to pick out the details of the face **(top)** and develop the tones of the head. Loosely block in the shape of the body using thin paint and a large brush **(above)**. Work up the colour over the whole image with pinks and browns and lay a thin layer of paint over the second animal **(right)**.

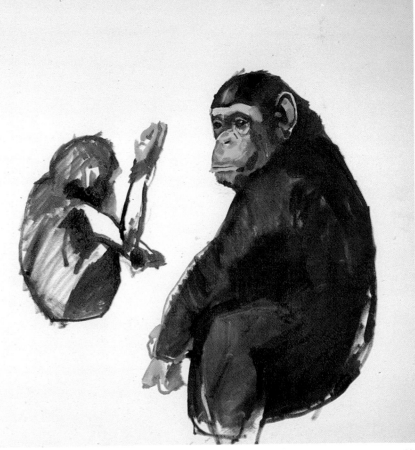

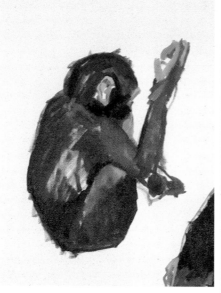

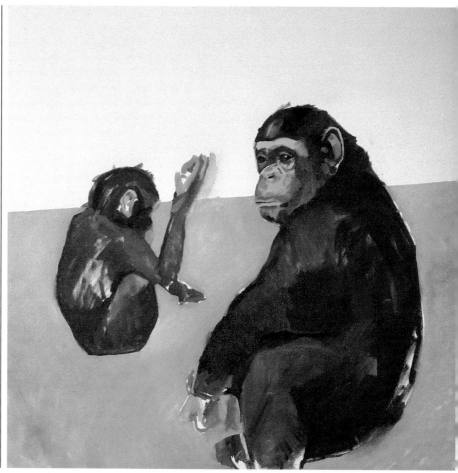

Bring up the tones of the second animal, gradually improving the detail of the form and intensifying the tones **(above)**. Fill in the background with a layer of thin paint, using masking tape to make a straight line **(right)**. Dab in multi-colour texture over the plain floor area **(below)**.

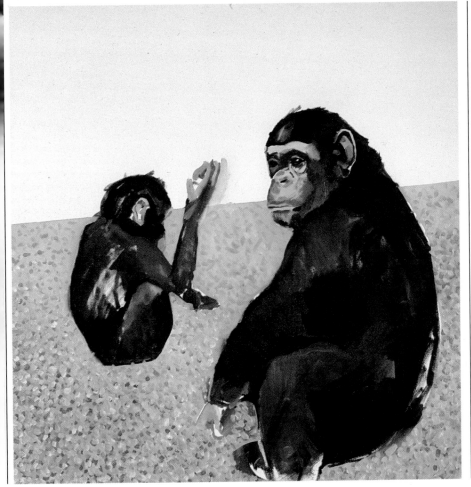

Use a fairly stiff large brush to spatter additional texture onto the floor area (**top**) *and continue to add more colour in the form of tiny red, pink, blue and yellow dots* (**left**). *Replace the masking tape to preserve the clean line between the floor and background* (**above**).

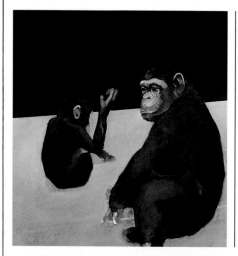 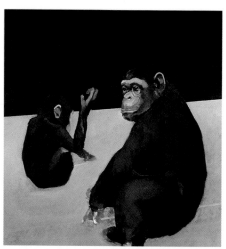

Scumble a thin layer of colour over the flecked floor, allowing some areas of dots to show through. Brush solid black across the background **(far left)**. Draw back into the details of the face and enrich the fur colours **(left)**. Draw up light brown shapes on the pink floor to suggest cast shadows, and complete the painting by adding highlights to the fur **(below)**.

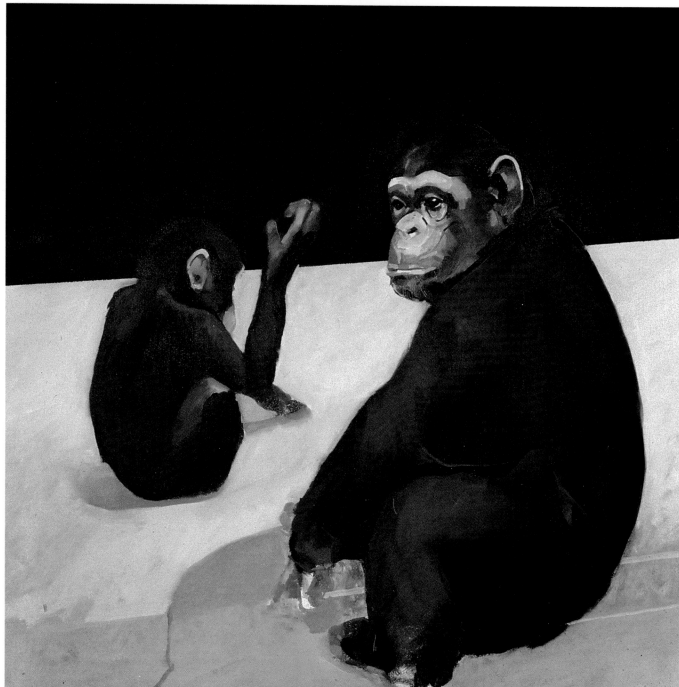

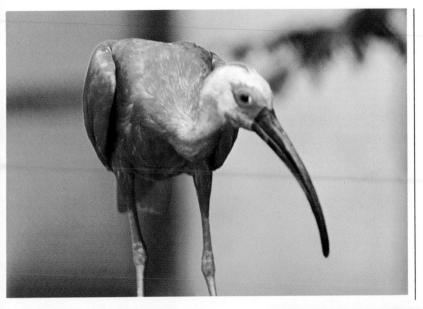

RED BIRD

Pastels are especially effective when used on a tinted paper. The darker background acts as a 'middle' tone and both deep shadows and white highlights can be used together to advantage. If the subject is a brightly coloured one, like the bird in this picture, choose a neutral tint for the paper to ensure maximum brilliance and impact from the pastel colours.

Outlines should be light and sketchy, merely providing a guideline for the eventual areas of colour. The pastels should be laid on in light strokes and the colours kept clear and pure. Overworking will result in a muddy, 'clogged' look. Spray the drawing with fixative whenever necessary to keep the colours bright and stable.

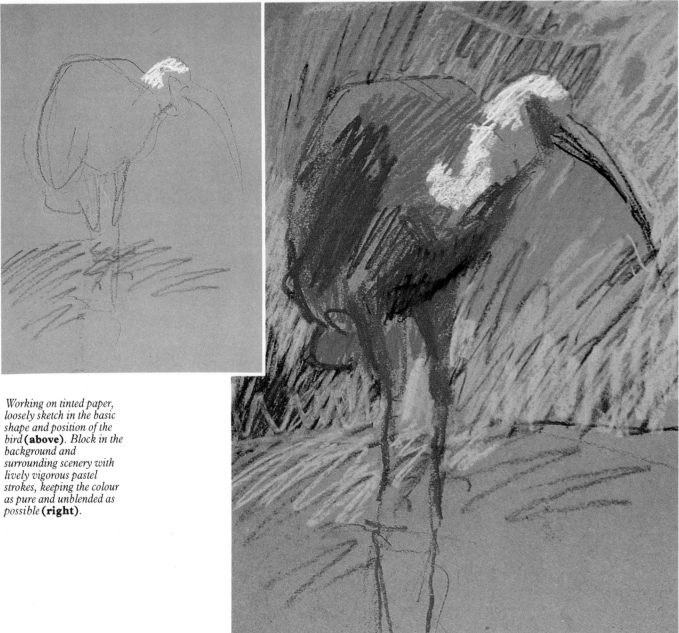

Working on tinted paper, loosely sketch in the basic shape and position of the bird (above). *Block in the background and surrounding scenery with lively vigorous pastel strokes, keeping the colour as pure and unblended as possible* (right).

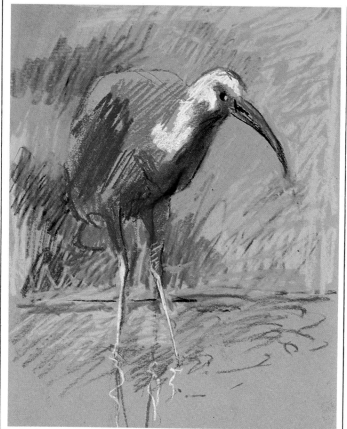

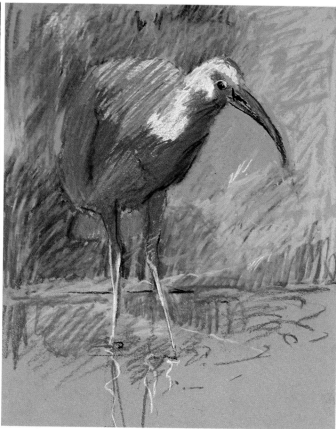

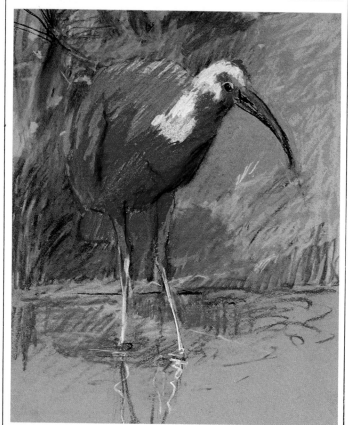

Strengthen the outline of the bird in black and darken the tone of the background immediately behind the subject **(top left)**.

Emphasize the colour across the entire image, depicting shadows and highlights and adding scribbled patches of colour **(top right)**.

Spray the whole drawing with fixative and let this dry. Strengthen the red shapes to define the form. Develop the background **(bottom left)**.

Use pale yellow to add loose lines of highlight, moving across the whole picture **(bottom right)**.

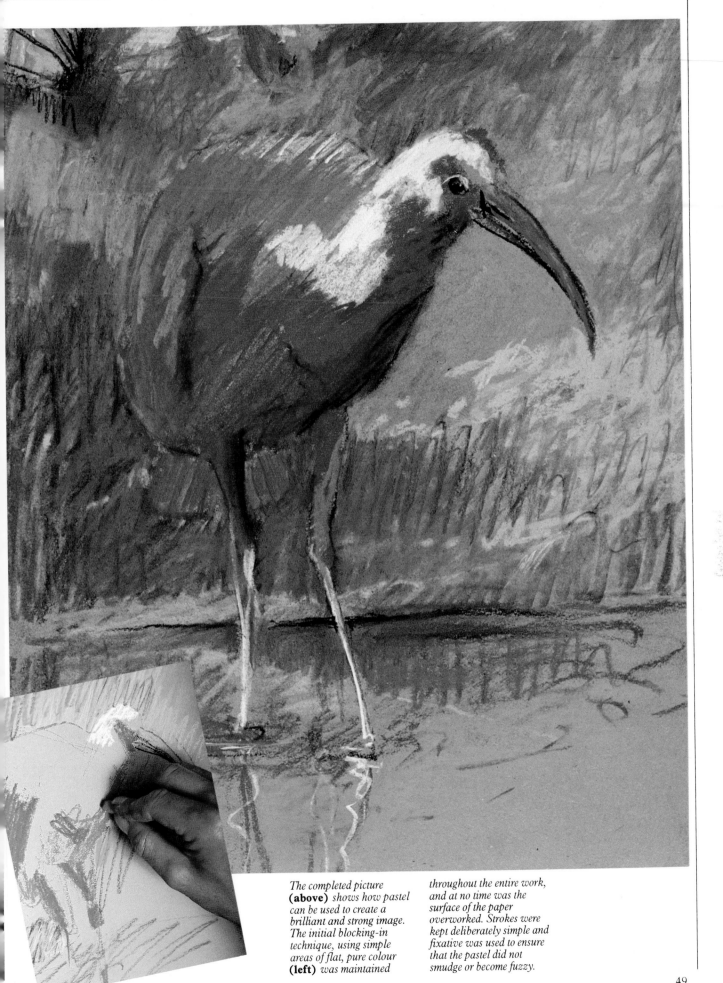

The completed picture (**above**) shows how pastel can be used to create a brilliant and strong image. The initial blocking-in technique, using simple areas of flat, pure colour (**left**) was maintained throughout the entire work, and at no time was the surface of the paper overworked. Strokes were kept deliberately simple and fixative was used to ensure that the pastel did not smudge or become fuzzy.

49

SLEEPING LION

A few judiciously placed lines and some
simple areas of colour can create an image
which is often more alive and convincing
than many more elaborate and
painstaking paintings which may have
taken days or even weeks to execute.

This simple, direct wash and line sketch
was done in minutes before the lion had
time to wake up and realize what was
happening! The artist used just one tube of
water colour paint and a soft lead pencil to
reduce the subject to its bare essentials,
creating a picture which is fresh and simple
in style.

Try to keep the image as clear and as
uncluttered as possible, eliminating detail
and putting into the picture only what is
absolutely essential to express the subject.

*Start by putting a small
amount of gold ochre water
colour paint directly onto a
piece of rag* (**above**).

*Rub the gold ochre onto the
paper to create general
colour areas. Use your
fingers and corner of the rag
to create the feathered
textures of the lion's fur
(**above**). Rub off any
excess colour (**left**). With a
soft dark pencil begin to
describe the lion's head over
the gold ochre paint,
varying the strength and
thickness of the line. Use
thicker lines for the strong
contours of the body,
thinner ones for hair texture
and internal contours
(**below**).*

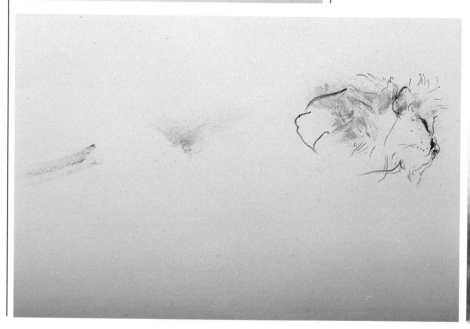

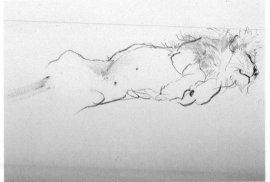

Hold the pencil in a relaxed manner and try to maintain the characteristic flowing lines of the subject as you develop the form (**far left**). Continue down the body of the lion with the same light flowing stroke (**left**).

Draw in the final details, such as the mane and the finer details of the body and limbs (**above**) and complete the drawing by reinforcing and redefining the outlines of the subject (**right**). Notice how the artist has disregarded the precise position of the yellow paint, and concentrated on the quality and accuracy of the drawing. The colour is a decorative embellishment to the pencil drawing.

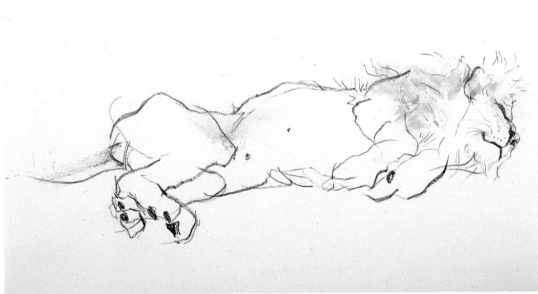

SEA SHELL

A single sea shell, with its complex structure and characteristic surface texture, provides a challenging subject for a Rapidograph drawing. It contains a variety of linear and tonal details, which the artist has carefully analyzed and reduced to a series of bold, essential outlines.

Although the drawing is well-observed and the artist's has payed close attention to structural detail, the rapidograph lines are fluid and relaxed. The informal result, which belies the underlying discipline of the drawing, prevents the finished work from looking too formal and technical, and preserves the natural form of the shell.

To use a Rapidograph successfully, you must have a light touch and hold the pen almost upright to keep the ink flowing. It is a sensitive and temperamental tool, giving a more consistent line than the traditional dip pen. Although it is used largely by

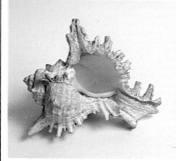

designers and commercial artists, the Rapidograph has gained popularity with many fine artists in recent years.

As a drawing instrument it has both advantages and disadvantages. On the positive side, you do not need to keep stopping to dip the pen in the ink — the Rapidograph has a reservoir providing a constant supply of ink to the nib. It is also less apt to cause blots than the old fashioned dip pen. However, many artists find the regular, mechanical line of the rapidograph difficult to manipulate, and it certainly needs practice and a sensitive touch.

Rapidograph drawing requires smooth paper or card. Normal watercolour supports or coarse drawing surfaces cause the nib to catch in the fibres of the paper creating a scratchy, unpleasant effect.

Rapidograph nibs come in a variety of sizes ranging from the extremely fine 0.1 to the broad 0.8. The nibs are very sensitive, being made of a fine, delicate hollow tube. They should be carefully handled and cleaned well after use with a special solvent cleanser to prevent them from becoming clogged. On no account should you use them with ordinary ink or drawing ink. Special Rapidograph inks are available which do not affect or block the nibs.

Hold the Rapidograph loosely, keeping it as upright as possible to allow the ink to flow smoothly and freely. Position the subject centrally on the paper and start to rough in the main outline **(above)**. *Look frequently at the subject, checking that each line is correctly placed in relation to its neighbour. Mistakes cannot be easily rectified, so it is important to decide where you are going to make a line and to do it with confidence. Your Rapidograph drawing should be accurate without looking too rigid* **(left)**. *Go over the major outlines to redraw and redefine the form and structure of the shell* **(bottom left)**.

Add small areas of deep tone with a series of tiny dots, gradually building these up to the correct density **(top left)**. Work into the form, developing the contours of the subject **(above)** and adding surface detail and texture **(left)**. The picture **(below)** shows the completed drawing. A minimum amount of line and tone is used effectively to create a sensitive and convincing image which captures the structure and texture of the subject to perfection.

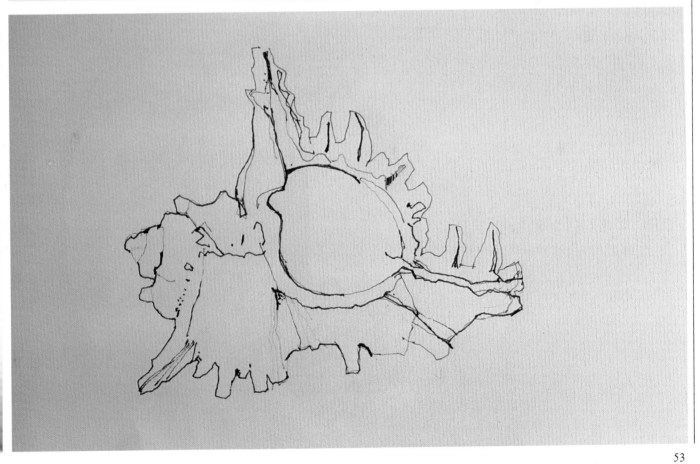

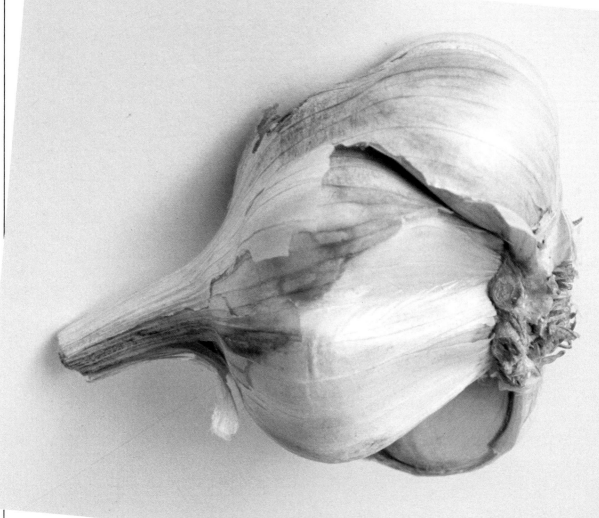

GARLIC

Acrylic is a versatile paint which dries almost instantly. It can be used either thickly and opaquely or transparently, like watercolour. Here the artist has chosen to use a pure watercolour technique by building up the subtle tones and colours of the subject in a series of thin, delicate washes.

Although acrylic used in this way produces a finished effect often indistinguishable from a water colour painting, it differs from the traditional medium in the way it handles. When dry, acrylic is insoluble and cannot therefore be blended into the picture. This means careful thought before a wash of colour is applied because, once dry, it cannot be removed or toned down except by covering it with thicker, opaque paint.

One very great advantage of acrylics is that it can be used with a far greater range of papers than traditional water colour — even relatively thin paper will not wrinkle or cockle unduly with diluted acrylic. This means you can start work immediately without the trouble of stretching paper or taping it to the drawing board.

Choose a limited range of colours for this exercise — the artist here used raw umber, yellow ochre, white, and Payne's grey. Mix the acrylic with water and block in some of the lighter areas using this thin wash. Keep the paint very thin for this initial blocking in to enable you to work into the image (**opposite page, bottom**).

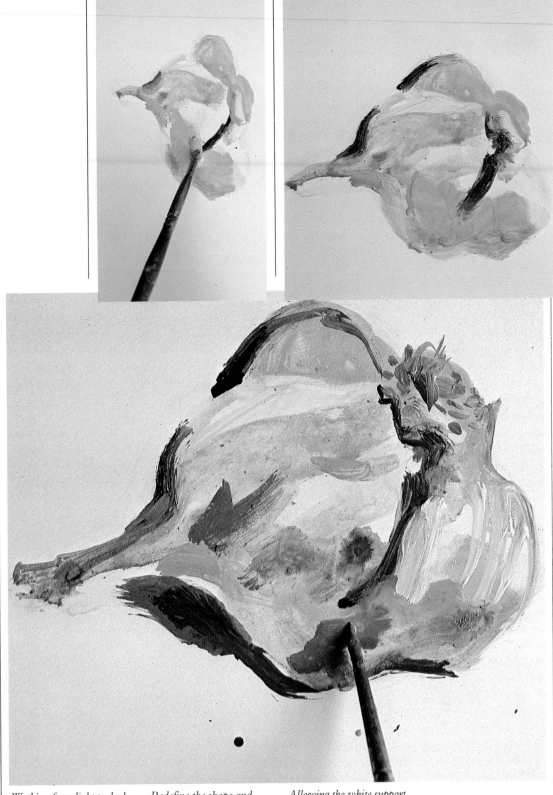

Working from light to dark, block in planes of shadow to suggest the form and contours of the subject (**top left**). *Again, the paint should be fairly runny, and the areas of colour loosely applied. Use a No.6 sable brush.*

Redefine the shape and introduce dark tones to emphasize the characteristic ridged form of the garlic (**top right**).

Allowing the white support to show through to represent highlight areas, complete the painting by touching in the darkest shadows (**above**).

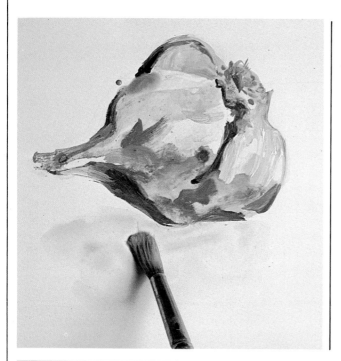

Using a soft sable brush, wet the area around the subject, ready to receive a pale wash of colour to indicate the reflected shadows.

*Flood the wet area with a very light wash of neutral grey. In the finished painting (**below**) these patches of light shadow emphasize the surface beneath the subject and give a feeling of space and solidity to the composition.*

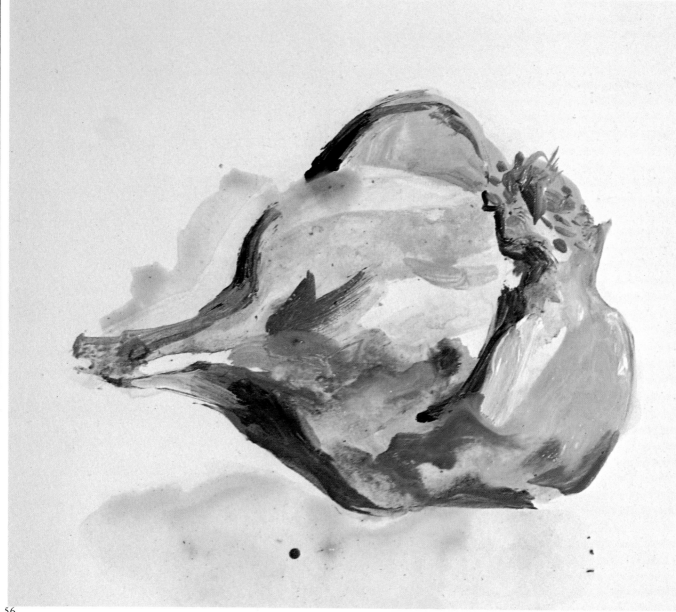

SMALL SHELL AND CONE

The smooth, mottled shell surface and jagged texture of the fir cone make these two small objects a challenging and interesting subject for a water colour painting.

Using broad washes of colour, the artist started by indicating the simple form and contour of the objects. By carefully copying each detail of texture and surface pattern, the diverse characters of the objects began to emerge. The shell is delicately tinged with red, yellow and grey, and the subtle tonal changes which occur as the light falls

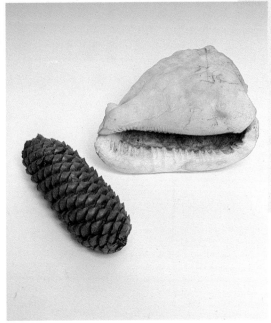

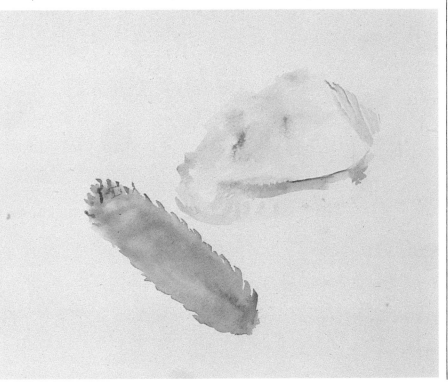

The subject for this water colour, a shell and pine cone (left), are made up of intricate textures and subtle patterns which call for close observation and attention to detail.

Lightly draw the shape of the cone using the tip of a number four sable brush, blocking this in with a thin wash of burnt umber mixed with a little Payne's grey (above).

Use a diluted wash to lay in the subtle, mottled colours of the shell. Use the tip of the brush to pick out the surface details on both objects (below).

over the undulating surface were carefully rendered. The mottled effect on the shell was achieved with the traditional water colour technique of painting 'wet into wet'. By laying one colour on another before the first colour is dry, the two colours fuse, thus avoiding a harsh edge to the paint.

The regular triangular shapes on the pine cone were drawn in with a fine sable brush, the colour being used transparently and sparingly to prevent the linear pattern becoming too dominant. Here the artist waited for the yellow wash to dry to ensure a crisply defined line.

Such precise work calls for the appropriate brushes. For this painting the artist used a number four and a number eight sable throughout, moulding the bristles into a sharp point between finger and thumb for the tiny lines and fine details. Sable brushes come in a range of sizes, from the extremely fine 000 — usually bought for specialist craft work only — to number 12. Water colour brushes are an important part of every artist's equipment and should be well looked after and washed after use.

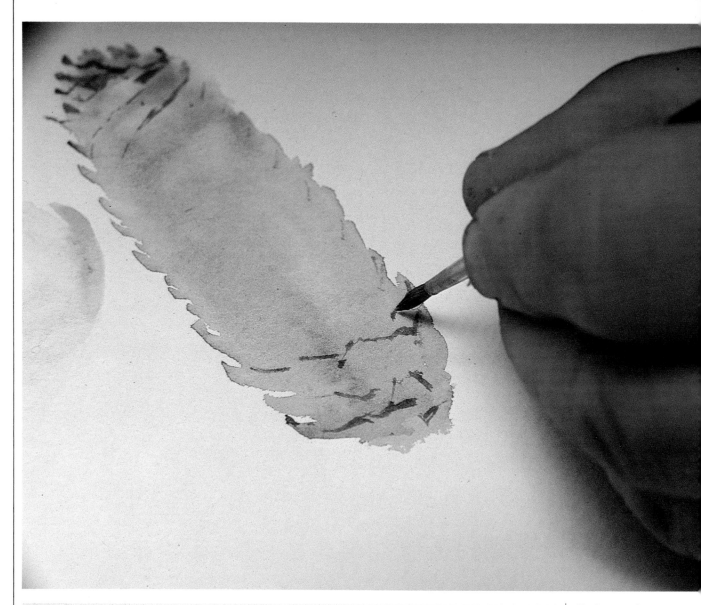

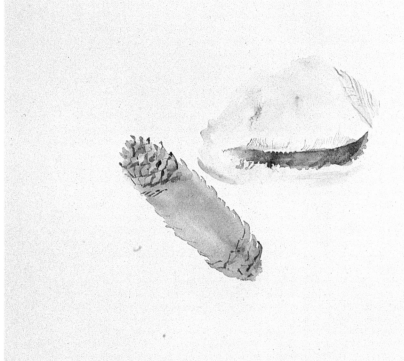

*Use burnt umber on a very fine brush to describe the details on the pine cone over the dry underpainting (**above**). Continue to work over the cone, using the direction of the brush strokes to describe the form. Strengthen the dark tone inside the mouth of the shell (**left**).*

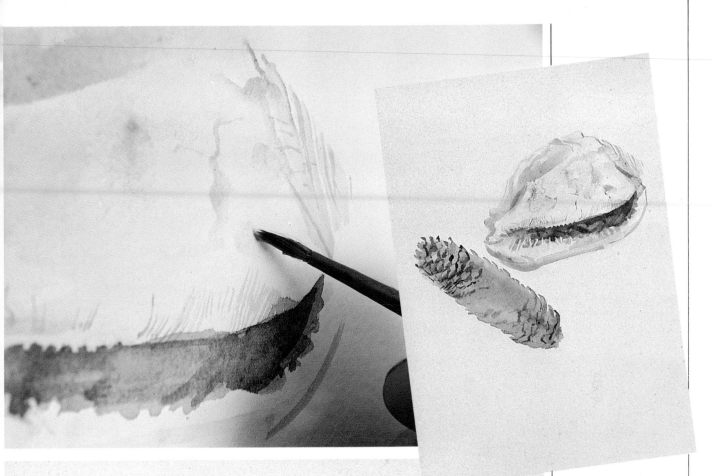

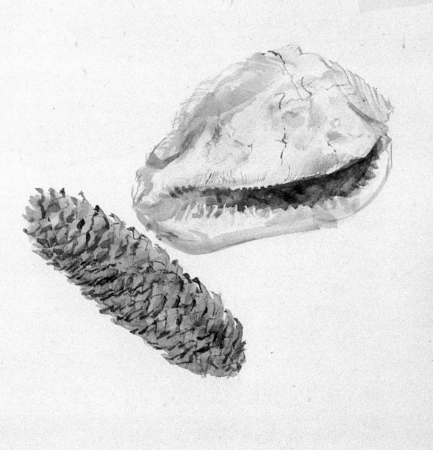

Continue to develop the subtle colour of the shell with washes of grey, brown and red. Use a very faint mixture of water and paint to start with (**above left**), gradually adding more colour for the darker tones (**above right**). Complete the picture by working over both subjects with line and wash until the patterns are complete (**left**).

BRACE OF PHEASANTS

The best way to find out which medium you like best is to try them all. Only by experimenting and practising with the various types of paint and drawing materials will you really get to know which are best suited to your personal requirements and to understand the properties and characteristics of the different media.

In this exercise you will be working from the same subject, but using a different medium for each picture. Our artist was lucky enough to have these colourful pheasants, but any subject which interests you will do equally well. The pictures here were done in acrylic, oil, gouache, pastel, and water colour, although these by no means cover all the possibilities. Eventually, for instance, you may want to go on to try charcoal, tempera, coloured pencil, ink, and some of the many new drawing materials now on the market.

Choose a suitable support for each picture. Oil can be done on primed canvas, hardboard or special oil paper. Acrylic should never be used on a surface prepared for oils, otherwise the paint eventually peels away from the oily surface, so use special acrylic primer or work on cardboard or paper instead. It is, however, quite safe to use oil paint on a support prepared for acrylic. Always stretch water colour paper before using gouache or water colour, otherwise the paper is likely to buckle and spoil the painting.

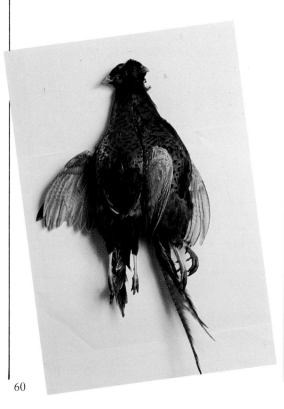

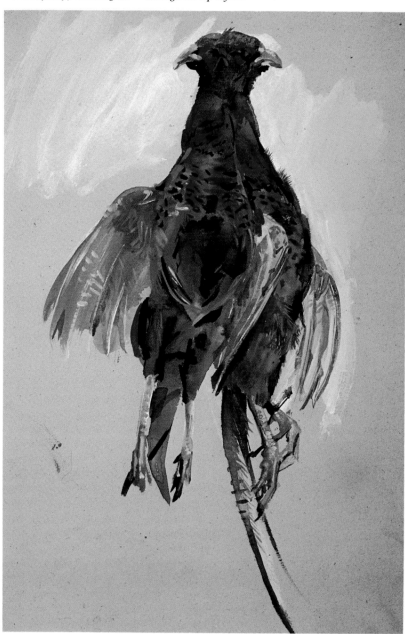

Use the paint more opaquely to give a light, feathery texture to the breast and body of the birds. The final result (below) achieves a degree of luminosity and brilliance which brings out the true colour of the brightly coloured pheasants.

ACRYLIC. *Traditional glazing with washes of colour is one of the most effective ways of using acrylic. Mix the paint with a little gloss or matt medium to bring out the full richness of the colour, and start to block in the main areas of the subject. Apply the washes freely, allowing the colours to run into each other for a natural, blended effect (above). One of the characteristic effects of acrylic painting is the shiny, glowing finish that can be achieved by laying transparent layers of paint over each other allowing the underlying colours to show through the top layers.*

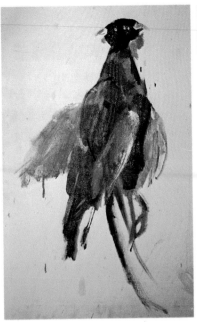

OIL. *Use a prepared primed surface for your oil painting. Start by blocking in the main areas of colour with thin paint which has been well diluted with turpentine* **(far left)**. *Introduce thicker colour, adding the wings and feathers and gradually building up the strength of the tones of the body and heads of the birds. Oil paint is more flexible than acrylic and takes much longer to dry. This means that the paint can be blended and manipulated on the picture surface for several hours after it has been applied. Take advantage of this property to build up the picture surface in a lively way, and to create an interesting, textural finish to the paint. Use a painting knife to apply broad, flat areas of solid colour* **(left)**, *using the side and point of the knife to scratch in the fine, wispy effect of the feathers* **(bottom left)**. *The finished oil painting* **(below)** *is richly coloured and densely textured, with the linear detail applied in solid strong colours to consolidate the form and give a feeling of solidity and substance to the subject.*

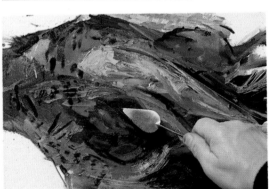

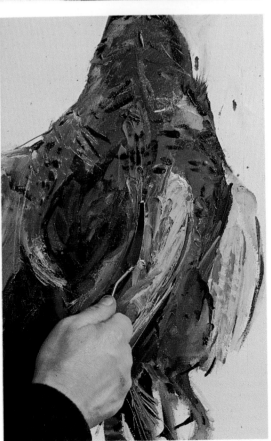

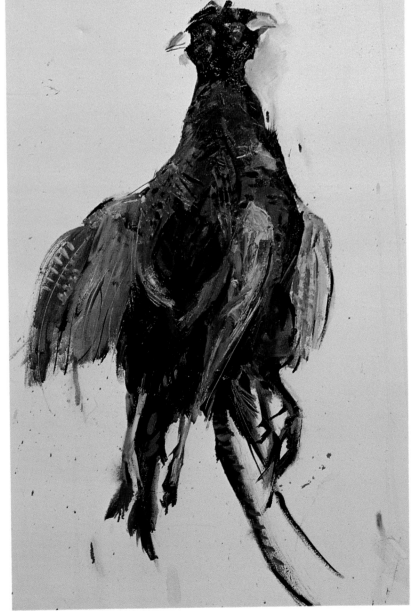

61

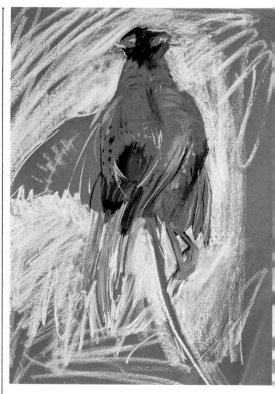

PASTEL. *Choose a tinted paper which will enable you to use very light and very dark tones to maximum advantage — the paper colour acts as a 'middle' tone and all other tones can be related to this. Use the pastel in a bold, confident manner, roughly blocking in the pheasants and approximate background tone* (**right**).

GOUACHE. *Gouache is simply opaque water colour and the effect it produces is not unlike that of matt oil or acrylic. The brightness and strength of the medium lies in its covering power and opacity, making it ideal for working from dark to light — an approach not possible with the more transparent water colour. Before tackling the subject, cover the paper with a warm, neutral tinted wash. This tones down the bright whiteness of the paper, enabling you to see and assess the colours more accurately without the distraction of a glaring background. Now start to block in the main areas of colour* (**above**), *allowing the wet colours to merge into each other occasionally, but otherwise keeping the colour as bright and pure as possible. The covering power of the paint makes it possible to put lighter details*

onto a darker background — use the side of a sable brush to paint the fluffy pink and mauve feathers over the brown base colour (**below**). *The opacity of these colours gives the finished work* (**bottom**) *a special clarity and beauty, typical of gouache painting.*

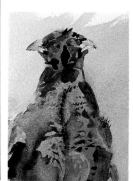

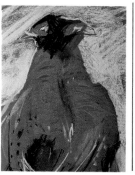

Intensify the colours by building up the layers of pastel (**left**). *Try to keep the colours separate and pure — overworking the pastels will produce a muddy, clogged effect.*

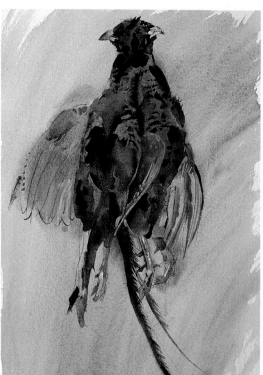

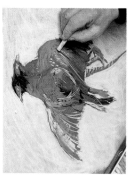

Add details in short, bold strokes (**above**) *and use fixative on the finished work to prevent the soft pastel colours from smudging* (**right**).

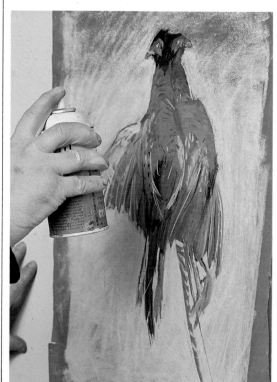

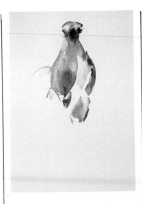
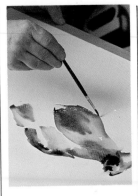
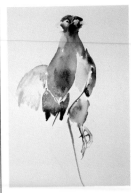

WATERCOLOUR

Transparency and the soft harmony of colour washes are the main characteristics of pure water colour painting. It is perhaps the most difficult medium for the beginner because mistakes cannot be corrected or painted over. However, the freshness and brilliance of water colour make it a technique well worth mastering. You must always work from light to dark when using water colour, never from dark to light which is possible with gouache, oil and acrylic. The whiteness of the paper must be used instead of white paint, and highlights represented by areas of blank white paper. Use weak washes — colour diluted with a lot of water — to establish the position of the subject and the main areas of tone and local colour **(below)**.

Allow the colours to bleed together, if necessary re-wetting the paper to enable the washes to blend and mix. This is especially effective where cool and warm colours are allowed to merge in this way **(top left)**. Redefine the edges of the subject using a fine sable brush to apply the paint **(top centre)**, and draw in the legs and tail feathers in fine, flowing strokes **(top right)**. Squeeze any excess moisture from the bristles and dab in the feather shapes with the semi-dry brush **(bottom left)**. Complete the painting by building up the texture of the feathers over the whole body **(below)**.

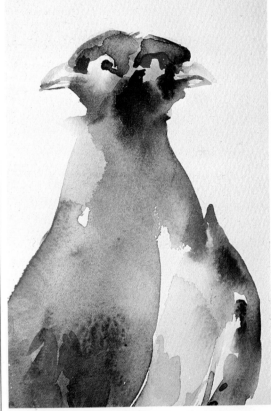

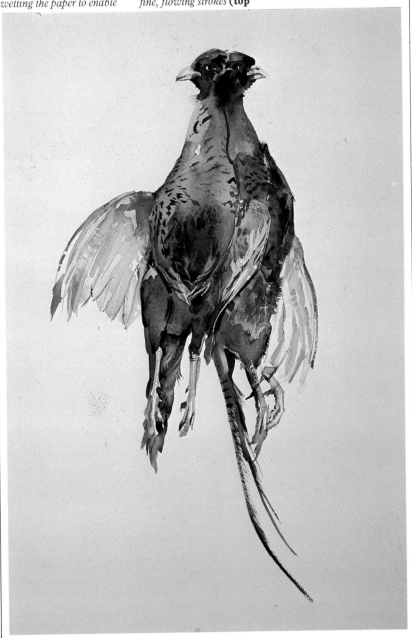

TEMPERA. *The chief qualities of tempera are its quietness and softness of colour. It is most popular for portrait and figure painting, but it has also been widely used for landscapes, still life and natural history subjects. Different tempera mixtures produce different results. Some tend to look flat, rather like gouache, while others, like the finished tempera painting of pheasants* **(below)**, *have the eggshell sheen typical of tempera painting. Approach the subject in the same way as the previous pheasant paintings — first blocking in the main areas of local colour* **(above left)**, *and working the detail and surface patterns into this* **(above right)**. *Tempera can be used loosely, as it is here, to produce the lively, natural lines of these birds,*

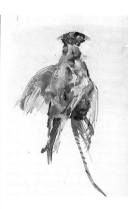

or it can be used in a tighter manner to build up precise detail and complicated surface pattern.

The artist took advantage of the rapid-drying quality of tempera to apply the paint quickly, keeping each colour separate from its neighbour to produce a spontaneous, yet crisp image.

CHARCOAL. *Your charcoal drawing should be rapid and lively, capturing the main lines and contours rather than any specific detail. Start by sketching in the outlines of the principle shapes using the broad side of the charcoal stick to block in areas of tone* **(above)**.

Apply more pressure to obtain the darker tones and shadow areas **(above)**, *taking care not to smudge and blur the drawing as you work, using the sharp edge of the charcoal for making lines.*

The finished drawing **(below)** *should be fixed to prevent the soft, powdery charcoal from smudging and to preserve the sharp tonal contrasts of the composition.*

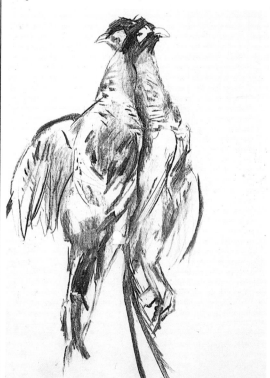

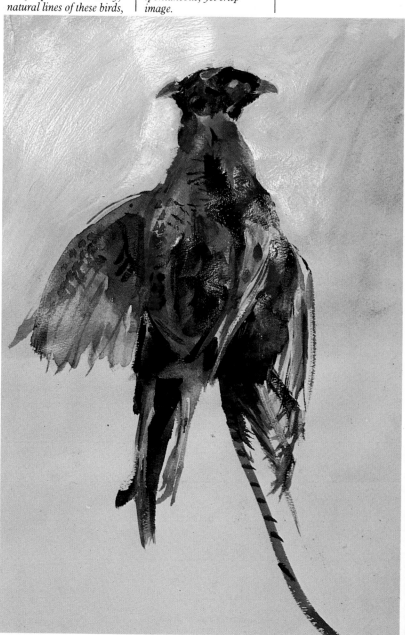